Basics of Video Lighting

Des Lyver and Graham Swainson

Focal Press
An imprint of Butterworth-Heinemann
Linacre House, Jordan Hill, Oxford OX2 8DP
A division of Reed Educational and Professional Publishing Ltd

\mathcal{R} A member of the Reed Elsevier plc group

OXFORD BOSTON JOHANNESBURG
MELBOURNE NEW DELHI SINGAPORE

First published 1995
Reprinted 1997

Text © Des Lyver and Graham Swainson 1995
Illustrations © Sarah Ward 1995

British Library Cataloguing in Publication Data
A CIP record for this book is available from the British Library

Library of Congress Cataloguing in Publication Data
A catalogue record for this book is available on request

ISBN 0 240 514 149

Printed and bound in Great Britain by Biddles Ltd, Guildford and King's Lynn

CONTENTS

INTRODUCTION

This book is aimed at you if you wish to learn about lighting a video production. We have assumed that you have no knowledge or, at best a little knowledge. We start at the beginning with the make up of the lighting team and who does what, continue through a little simple electricity that you must know to understand the relationship between the camera and the lights and then move on to basic lighting in the studio and on location.

We end up with some practical examples to help you light the most common productions. They are not the whole answer, but will provide you with a viewable starting point!

It is equipment non-specific, merely dealing with the principles and processes involved in obtaining professional results in educational and training environments. You will not be a 'lighting expert', but if you are a student who wishes to learn about all aspects of lighting a video production, read on.

Much of what you read will be directly transferable to film courses as the basics and principles remain the same.

There are brief, but comprehensive, details of the types of equipment you will encounter. There are hints and tips to help you choose equipment to fulfil a particular need.

You will learn enough about the planning, selecting and positioning of lights to make your own productions look very professional.

Our aim is to give you a rapid understanding of what is actually a complex process, without getting too bogged down in technical terms. Only where it is necessary to understanding is there any reference to technical matters.

How to use this book

Whilst you may choose to read this book from cover to cover, it is essentially designed as a 'dip in' book. You will see that the beginning pages are concerned with the lighting team, followed by essential electricity and how the camera 'views' light. We move through the different types of lights, and their control, to their basic settings for studio and locations. Finally there are examples which will help you to light your different types of production.
It is possible to read only the section that interests you at the moment without reference to the other sections.

We have both spent many years in the video industry, and now teach video production at all levels. We wrote this series of books on the video production process as a result of being unable to find a 'starter book' that we could offer our students. Thank you for buying it. We hope you find it useful and that you have as many happy years in the industry as we have.

Acknowledgements

We would like Strand Lighting for their help and permission to use some of their diagrams.

We would also like to thank all our friends in the industry who have offered their help to us over many years.

Des & Graham

1

THE LIGHTING TEAM

In the beginning there was darkness.

When asked what he did for a living, a lighting director once said 'I paint with light'. This concept of using light to create the visual effect required by the camera is so simple that it is often overlooked.

Much as a painter knows the materials available and makes choices about what to use, and when, so must anyone concerned with lighting for video.

THE TEAM

Television is made of pictures and sound. Pictures come from cameras. Cameras need light to see. Whilst on location there is often plenty of light around 'accidentally', from ambient daylight, room lights, etc., in the totally controlled environment of a studio light has to be provided for the cameras. This is the job of the lighting team.

The lighting team consists of a lighting director, lighting operator and sparks led by a gaffer. Often in small studios this is all done by one person. Sometimes, particularly on location video or film shoots, the role is combined with camera operator to become lighting camera operator.

If we look at the full team in the studio the lighting director is the person with overall responsibility for designing the lighting, and for supervising its installation and operation. The lighting operator is the person who controls the lighting system during the programme. With modern lighting and control systems this can be quite a complex job.

The sparks are the people who actually rig the lights, and the gaffer is their supervisor. In the past sparks have had an unjustified reputation for being basic, and perhaps insensitive souls, with no understanding of the niceties of television aesthetics, but it is worth remembering that their understanding of how to place lights, whilst dealing with extreme heat, complex electrical installations, dangerous voltages and perilous heights, has made possible the delicately beautiful shots of many a director.

In reality, most small studios cannot sustain a large lighting team, so we will try to help you learn how to do everything!

It is vital that the lighting director understands the two requirements of lighting so that she or he can harmonize their solutions. These are the need for illumination so that the camera can see useful images, and the need for some kind of atmospheric interpretation, so that the image conveys powerfully the required message.

On location this simple definition of what the lighting team do can have the added complexity of a large amount of light already there, provided by many sources — ambient light! It will almost certainly be in the wrong place, from the wrong angle, of the wrong quantity, and probably of the wrong colour! To overcome this problem the lighting team's tools are reduced to the barest minimum that can be carried. If the lighting designer paints with light, on location somebody has already scrawled on his canvas, and he only has one brush and and a few tubes of paint.

But, despair not, because, sometimes the previously scrawling artist is a Turner or a Rembrandt, who has laid the most exquisite foundation to build on.

TYPES OF LIGHT

There are two types of light (Figure 1.1), natural light (originating from the sun) and artificial light (originating from a man made source). You will notice that artificial light does not have to be a 'spot light'. Long before electricity man was using fire as light. Fire and light must be considered together because most light sources are extremely hot and wherever there is light there is a risk of, at best, burnt fingers and at worst, an unwanted fire.

(a) (b) (c)

Figure 1.1 (a) Natural light comes from the sun. (b) Where there is fire, there will be artificial, or man made, light. (c) A spotlight is a specially made, controllable, artificial light source

There are two other factors about light that we know, but seem to forget. One is shown in Figure1.2 where a light is obstructed (the sun by cloud, or a spot behind a curtain) the result is darker and more diffuse. With any light source it is possible to reduce its intensity, but not increase it or increase its diffusion, only to decrease the diffusion with the aid of lenses. This results in a vast selection of lights that are designed for specific purposes.

(a)

(b)

Figure 1.2 (a) Here our sun is obscured by the cloud. The result is less light, but also less shadow. (b) If we put the spotlight behind a translucent curtain we get the same effect, less light but more diffuse

The other is that not all light burns with the same colour. An electric fire that is designed to last for years will be deliberately 'under run' and will only heat up to 'red' hot, radiating invisible infra-red light. A light bulb is 'over run' to produce the effect of 'white' hot to produce light with a visible yellow radiation (with a by-product of heat), but has a much shorter life. In fact, as we will explain later, our eyes deceive us into believing that the bulb is producing white light.

It is very important that the lighting team realize that there is no such thing as white light. As with selecting a particular colour-sensitive film, the video camera has to be told what colour the light actually is in order that it can 'think' the light is white and thus reproduce all the other colours accurately. This means that an understanding of 'colour temperature' is needed.

Thinking of the fire (red) through to daylight, Figure 1.3 gives some figures for common light sources. A fuller explanation of where these figures come from can be found in more technical books, but from the beginner's point of view it is only necessary to know that the video camera must be set to react to the light source

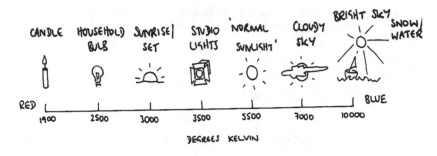

Figure 1.3 The Kelvin temperature scale to measure the colour quality of light sources. Note that an overcast sky is not the same temperature as a clear blue sky

as if it were white. This is done using the 'white balance' on the camera when the camera is 'shown' a pure white card in the light being used and adjusted to make the card appear white on the screen. Film cameras are adjusted by altering the film stock, or using coloured gels to correct the light.

The colour temperature of a light is measured in a scale using degrees Kelvin (°K). Manufactured artificial lights are normally made to produce light of 3,200°K, which is the 'standard' figure for artificial light, but there are some which produce 5,600°K, which is the 'standard' figure for daylight.

Mixed lighting

Major complications will occur if mixed lighting is involved, for instance if daylight is coming through a window and the interior is lit with artificial light.

It should be understood that different colour temperatures cannot be added up to get a resultant overall temperature. The colour temperature in a particular area is dependent on the source lighting it. This will lead to pools of daylight around a window being at a different colour temperature to areas further into the room.

In the example above if the camera is set to react to daylight as white, anything seen outside, and immediately inside, the window will have the correct colour, but anything seen in the interior will be recorded as the colour it really is; in this case orange to red (Figure 1.4).

If the white balance is set to artificial light to render the interior colours correct, then anything seen through the window will be blue (its real colour) (Figure 1.5).

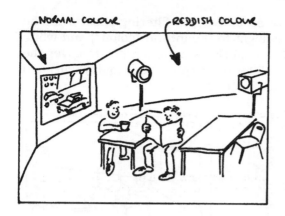

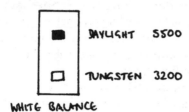

Figure 1.4 Because the white balance is set to daylight (5500°K) this scene will appear to the camera as normal colour reproduction outside the window, but the interior will appear more orange than it really is

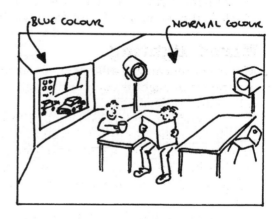

Figure 1.5 Now the white balance is set to artificial light (3200°K), the same scene has the correct colour rendition inside, but the scene outside appears very blue

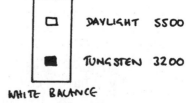

5

The options are to use an orange/red filtering sheet over the window (to correct the sunlight to the interior colour) and white balance for artificial light, or, perhaps more simply, to cover the artificial lights with a blue filter (to correct them to daylight) and white balance for daylight (Figure 1.6).

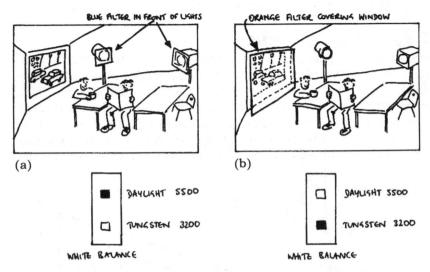

Figure 1.6 (a) With the camera set to daylight, we have corrected the interior light with blue filters over the interior lights. (b) With the camera set to artificial light, we have corrected the daylight with an orange filter over the window. Both solutions will produce the correct rendition of all the colours in the scene, both indoors and outdoors

It is unhelpful to think of white balance as having settings for 'indoors' or 'outdoors' because, realistically, any work done outside a studio will involve mixed lighting. What is helpful is an understanding of the artistic possibilities of a deliberately incorrect balance for effects to show, for instance, a warmer glow to an interior or a bluer, colder, outside in winter.

Electrical lights will usually use incandescent tungsten filaments (hence tungsten lighting), although some light sources have a colour temperature of neither daylight or tungsten and should be avoided unless required for specific effects. The most often encountered in location video are fluorescent lights (tendency towards green) and sodium or mercury street lights (anything from brown to purple).

Bulbs with tungsten wires in the envelope are known as filament lights and will have a colour temperature of between 2,700 and 3,200°K. There are also 'discharge' lamps which have several advantages over tungsten, or filament, lights. Discharge lamps

produce about four times the light output per watt of filament lights. This means they are brighter watt for watt, or, alternatively, they run 75% cooler for the same brightness. Discharge lamps (such as the HMI, CSI, carbon arc and xenon) also run at a colour temperature of around 5,500°K, the same as daylight, and may be preferred for large interiors when mixed lighting is involved.

Light and distance

As with the sun, all artificial lights become less bright with distance. The simplest way of thinking about this is to realize that light spreads out over distance and, therefore, there is less light for a given area as distance increases. This is defined by the inverse square law which states that the fall off in light level is equal to the increase in the distance squared (Figure 1.7). In practical terms this can be used to control amounts of light by remembering

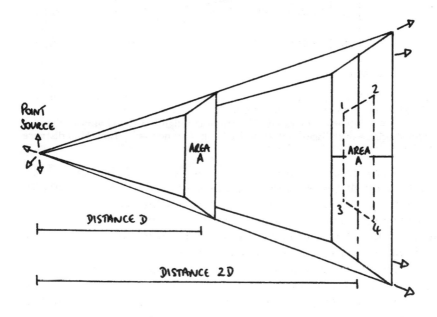

Figure 1.7(a) As the distance from a point source of light increases, so will the spread. At twice the distance, it has spread out enough to cover four times the original area. This same amount of light can, therefore, only illuminate this larger area with a quarter of the original intensity. It is equally true that if you take the amount of light falling on the larger area and halve the distance from the light source, four times the amount of light intensity will fall on this smaller area. Moving the distance of a light within a scene will give us control over how much light falls on the area to be illuminated

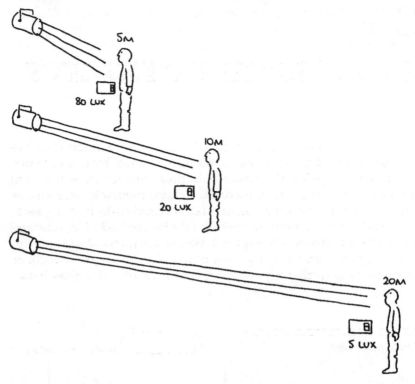

Figure 1.7(b) Inverse square law. The change in light level will vary at the inverse square of changes in distance: Double distance = $^1/_4$ Lux; Half distance = 4 Lux

that if the distance between light and subject is doubled, for instance from two metres to four metres, the light intensity (at the subject) is reduced to a quarter. If you have a shortage of light it is equally true that if the distance between light and subject is halved, the light intensity is four times greater.

2
A LITTLE ELECTRICITY

A little basic grounding in electricity will help in understanding why artificial lights are rated in watts. A voltage, from the mains or a battery, supplies the pressure to cause electrons, in the form of an electric current, to move around. How many electrons move is dependent on how much resistance is offered to their movement. All metals have a resistance which can be controlled by altering their length or diameter (Figure 2.1). The metal in a bulb is in the form of a piece of wire — the element — which may be straight or coiled to achieve the required length to fit within the glass bulb.

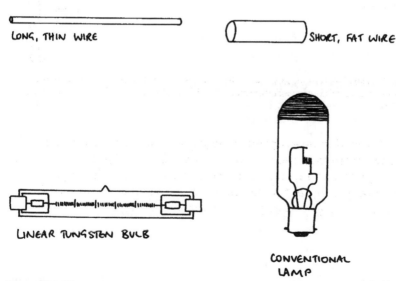

LONG, THIN WIRE

SHORT, FAT WIRE

LINEAR TUNGSTEN BULB

CONVENTIONAL LAMP

Figure 2.1 The resistance of a piece of wire is determined by the material it is made from, the cross-sectional area of the material, the length and the temperature of the material. The thin, long wire will have the same resistance as a proportionately fatter, shorter wire. When used in artificial lights the filament may be long and coiled up to fit into a smaller space or it may be one length, resulting in a longer bulb. Thicker wire has less resistance and so produces less heat and light for a given length. In practice lamps are optimized to give the highest possible lumens to watt ratio. Filament diameter and length is selected for optimum light output and mechanical strength

Ohm's law gives the mathematical formula to find the voltage, or current, or resistance from the other two (Figure 2.2). It is expressed as $V = IR$ where V is the voltage, I is the current (in amps) and R is the resistance (in ohms). The formula is easily transposed into $I = V/R$ or $R = V/I$. The current (I) in amps is very important because fuses are measured in current carrying ability (5 A, 13 A, 15 A, etc.).

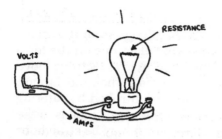

Figure 2.2 Ohm's Law allows us to find the current taken by a light (I measured in amps) by calculation from the voltage (V measured in volts) and the resistance (R measured in ohms). Although the basic formula is $V = IR$, it can be transposed to give $I = V/R$ or $R = V/I$

The fuse protects the equipment from possible damage, or fire, and must be rated at just above the current required by the light being used. The electrical cable supplying the light has a current carrying capability of its own and must not be forced to take more, the correct fuse rating protects the cable as much as the light. It is, therefore, very dangerous to fit a bulb needing more current than the light is manufactured to use.

Another formula is used to find the power of the light in watts. If the voltage is multiplied by the current the result is expressed in watts, so $W = VI$. In the example (Figure 2.3) it can be seen that our light with a coil resistance of 48 ohms giving a current of 5 amps when connected to the mains of 240 volts results in a power rating of 960 watts (to all intents and purposes a 1000 watt or 1 kilowatt light).

The fact that lights are quoted in watts is not much help. We need to know the current taken, to work out the fuse rating, and the voltage, so that we use exactly the right amount of electrical pressure. A 2 kilowatt light does not necessarily produce twice the output of light as a 1 kilowatt light; there are other factors to be considered. It is important to a lighting person to understand that increasing the power of a light will increase the light output, but not by a linear factor.

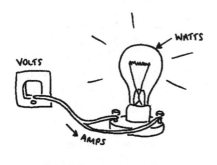

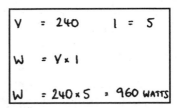

$$V = 240 \qquad I = 5$$
$$W = V \times I$$
$$W = 240 \times 5 = 960 \text{ WATTS}$$

Figure 2.3 The power rating of a lamp is measured in watts (*W*). To find the watts we first need the volts (*V*) and the current (*I*). The basic formula is *W = V*I*, but, again it can be transposed to find a missing value from the other two. To find the voltage the formula would become *V = W/I* and to find the current *I = W/V*

If lights are being powered by batteries it is more important to know the amps the light will need. Batteries are quoted not only in voltage, but in amp/hours. This is a measure of how many amps a battery can supply for how long. It is essential on location that this is calculated. Figure 2.4 shows the relationship of a 5 amp light connected to a 1 amp/hour and a 5 amp/hour battery.

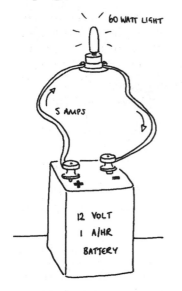

BATTERY IS 1 AMP/HR 12 V

60 WATT LIGHT = 5 AMPS

1 AMP FOR 1 HOUR

5 AMPS FOR 1/5 HOUR

BATTERY LASTS 12 MINS

Figure 2.4 Here a 12 volt light, taking 5 amps, is connected to a 12 volt battery. The battery is rated at 1 amp/hour. This means it will give 1 amp for 1 hour, before it needs re-charging, or, with this light connected to it, 5 amps for a fifth of an hour (12 minutes). If the battery was rated at 5 amp/hour then it would give 5 amp for 1 hour and our light would last for 1 hour before the battery went flat

A LITTLE PHYSICS

The brightness of a particular light is most usefully described by considering its light output. Light output is measured in lumens and is related to the electrical power of the light (in watts). Many manufacturers now quote the light output of their lights by supplying a figure of 'lumens per watt'. This is useful because it allows judgments to be made between one light and another. There is a very complex relationship between the voltage applied to the light, the current it takes (hence the watts), the colour temperature and the life of the bulb (Figure 2.5). A very small reduction in the applied voltage will have a negligible effect on colour temperature and could double the life of the bulb for very little loss of light output.

When a tungsten light is burning the tungsten filament starts to evaporate. This condenses on the cool parts of the bulb and forms a black layer. This, in turn, raises the temperature of the bulb and eventually moisture forms. The oxygen in the moisture attacks the filament and forms tungsten oxide which causes more blackening, repeating the cycle until the bulb is almost completely black and the filament melts (bulb blows). Most modern lamps include a halogen (chlorine, iodine or bromine) which react with the tungsten to provide a transparent substance. While this prevents blackening the filament still becomes thinner and consequently melts.

To extend the life of a bulb, it has been discovered that if the bulb wall is kept above about 250 °C the tungsten halide is carried back to the filament, allowing the tungsten to re-form. Because the tungsten cannot be guaranteed to re-form at exactly the place from which it was lost, there will eventually be a weakening of the filament causing the bulb to blow.

In order to sustain the high bulb temperatures, large glass areas have been replaced by small quartz envelopes. This is the reason that modern lamps are small and known as quartz halogen bulbs.

Bromine filled lights are not suitable for use with dimmer circuits because the reduction in power, causing a reduction in envelope heat, causes the bromine to corrode the tungsten causing shortened life.

Cleanliness is a very important factor in the replacement and handling of quartz lamps. The smallest amount of sodium (found in fingermarks) will destroy the quartz damaging the optical quality and shortening the life of the bulb.

The filaments of modern lights, particularly high power lights, are very thin and run at extremely high temperatures. Care should

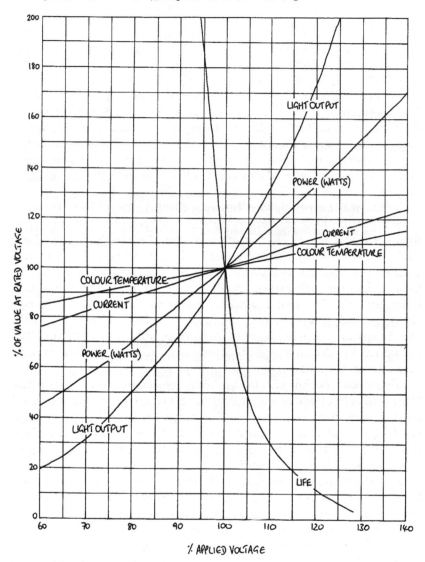

CHARACTERISTICS OF TUNGSTEN HALOGEN LAMPS

Figure 2.5 There is a quite simple relationship between an increase, or decrease, in voltage applied to a light which affects the current and its actual output and life expectancy. You can see that an increase in voltage from 240 v to 252 v (5%) results in 20% more light at the expense of 50% of its life. If we ran the lamp at 228 v (a reduction of 5%), we would get slightly less than a 20% loss in light but increase its life by 100%

13

DICHROIC MIRROR LAMP

CONVENTIONAL LAMP

TUNGSTEN-HALOGEN LAMP

Figure 2.6 This is the size relationship between a standard tungsten lamp, the smaller QI (quartz halogen) equivalent and a QI fitted into its integral mirror. These mirrors are known as dichroic because although light is reflected forwards from the mirror, the infra red (heat) rays pass through the back of the mirror. This can reduce the heat from the front of the light by as much as 70%

be taken to protect them when hot, as any sudden jolting will fracture the filament. When the lights are finished with, they should be switched off before any other equipment and allowed to cool down properly before being moved.

Low voltage lights, run from batteries, are very suitable for location work for several reasons. The disadvantage of the voltage being lower and therefore the current being higher, for a given wattage ($W = VI$), means that the filament will have to be thicker and smaller. A thicker filament will have a longer life and be more resistant to movement. Because the bulb is smaller it is possible to fit the bulb inside a mirror to give a more powerful and concentrated light output (Figure 2.6). In practice a 100 watt low voltage (12 volt) light will have approximately the same output as a 500 watt (240 volt) light.

3
THE VIDEO CAMERA

Video cameras are simply devices which can convert the images we see into electrical images that can be recorded onto magnetic tape. The two main ways of doing this are either by using cathode ray tubes (tube cameras) or charge coupled devices (CCD cameras).

All cameras have a lens, which helps to control and shape the image achieved. The lens will have at least two controls, focus and aperture (or iris).

The focus allows for change of distance from the subject to the camera, to keep the significant part of the image clear. The aperture controls the amount of light getting into the camera and so is crucially connected with the effect of lighting. A variable size hole (called the iris) allows more or less light in. The numbers (f-numbers) on it are in a scale such that each step halves (or doubles) the amount of light let in. Perhaps confusingly the numbers of this scale get smaller the bigger the hole is, so, for instance, f4 lets in twice as much light as f5.6.

Immediately behind the lens the image is broken into three separate colours — called primary colours — red, green and blue. The amounts of these are measured. The right amounts of red, green and blue will result in white. If the percentage of these colours is altered, the result will not be interpreted as white.

The three colours can either go into one pickup (tube or CCD), by means of a specially striped filter, or into three separate ones (one for each colour) depending on the design of the camera.

Single tube (or chip) cameras (Figure 3.1), whilst lighter and cheaper, cannot resolve such fine detail, nor keep such good colour saturation as three tube (or chip) equivalents (Figure 3.2), since the striped filter necessarily imposes a limit.

Between the back of the lens and the pickups is a colour balance filter wheel which, by passing the image through one of a set of coloured glass discs, provides the first (coarse) correction of the response of the camera to different coloured lighting.

Tube cameras are said to be smoother in their response to fine gradations of lighting difference than CCDs, giving a more subtle image, but they have few other advantages, and are rapidly being superseded by CCDs.

SINGLE TUBE CAMERA

Figure 3.1 Single tube camera

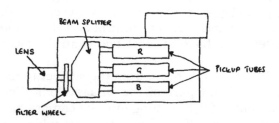

Figure 3.2 Three-tube diagram

3 TUBE CAMERA

CCDs (Figure 3.3), unlike tubes, are physically robust, and much more tolerant of extreme light levels than tubes. Being smaller, and less hungry of voltage than tubes they allow cameras to be more compact, and less demanding of scarce battery power (on location) than their tube equivalents. From a lighting point of view they also have the considerable advantage of being more sensitive (thus needing less light to deliver a good image) and having a wider contrast ratio (thus being more tolerant of variation between dark and light parts of the scene).

In a naturally lit bright scene, there is a great variation in level between the brightest and the darkest portions. This difference is known as the contrast level of the scene. Our eyes can take in a tremendously wide contrast range, but video cameras are much more limited.

In order to capture a good video image, the contrast level between the brightest and the darkest needs to be limited, but not to such an extent that it is eliminated. We can't do much about the brightest levels outdoors, in natural light, but may need to make a decision to allow the darkest to appear totally black, or whether to add a little light in the shadow areas, to reduce the contrast level, and thus allow the camera to 'see' into the darker areas.

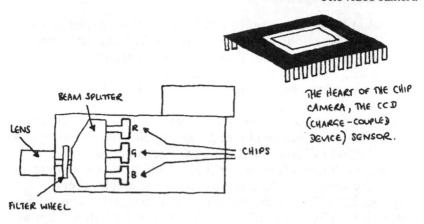

THE HEART OF THE CHIP
CAMERA, THE CCD
(CHARGE-COUPLED
DEVICE) SENSOR.

3 CHIP CAMERA

Figure 3.3 CCD diagram

Location work indoors, or in a studio, needs very careful setting of these levels of light and dark to obtain the correct balance. Artificial lighting, therefore tends to start with a fairly high level of light overall, with the areas we want brighter given just a little bit more illumination to make them appear brighter.

THE HUMAN EYE AND THE VIDEO CAMERA

It will help to understand the subtleties of lighting if we consider the differences between the camera and our own eyes.

The camera is optically very similar to our eye, but electrically very different. The eye has a lens, enclosed in the eyeball, and we use muscles to alter the shape of the lens thus altering its focal length. We have an iris, a variable sized opening, to control the amount of light entering the eye. The image is produced on the light sensitive rear surface called the retina. The nerves attached to the retina send electrical signals to the brain, which allows us to 'see'.

Like any optical system the image is inverted and the brain has learnt to interpret it as the right way up. We have also learnt to interpret what we see in the way of colour, but the brain actually misleads us. Because of the sensitivity of the eye to colour not all colours are seen equally brightly. Although the primary colours of red, green and blue will make white our eyes need 30% red, 59% green and 11% blue to mix the colours to white. Because we have

learnt what white is our brain will tell us that an object is white even when the colour temperature of the lighting has actually altered the colour reflected. This is noticeable at sunrise or sunset for instance. It is also true in a video studio, where the colour temperature of the lighting is such that a white shirt is actually slightly red.

On the other hand a camera interprets the quantities of light it sees as equal percentages of red, green and blue which do not add up to 'our' white unless adjustments are made to alter those percentages. This is the reason that a 'white balance' must be done every time the colour temperature of the light alters.

Unlike our eyes, the camera lens can be altered to give a wide angle or a telephoto view of the world. We need additional lenses, such as binoculars, to achieve this distortion of the viewpoint.

Because we have two eyes, with a fixed distance between them, we see things from two angles. This allows us to see depth, the distance between an object and its background, we see three dimensionally. The camera only has one angle of view and sees in two dimensions. It is a function of the lighting to suggest depth.

Lighting operators must be aware of contrast ratio. Contrast ratio is the relative level between the lightest and the darkest part of a scene. Our eyes can interpret enormous ratios of light and dark but the camera is very limited. As we will now see, depending on whether the light sensing device is tube or CCD a larger or smaller overall light level will be required before the camera can see at all. Even if the light is sufficient for our eyes to see the camera may see black. As the light level increases the electrical output of the camera increases in direct proportion until it saturates. It is at this point that the brightest parts of the picture 'burn out' and it is no longer possible to make out detail.

At best a contrast ratio of 1:64 should be achievable. It is worth remembering the contrast ratios of two common scenes: A scene shot from inside against a window has a contrast ratio of up to 1:1000 and a landscape against direct sunlight about 1:100. In either case if additional lighting is not available, decisions will need to be taken about what should be 'seen' as black and what is allowed to burn out.

WHAT THE CAMERA NEEDS

We know that light output is measured in lumens. This is not much help when we want to know how bright an area is. We need another measurement which relates to how much illumination there is in the scene. The unit used is the lux. One lux is the amount

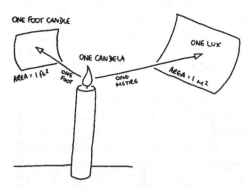

Figure 3.4 One lumen illuminating a square metre at one metre to give one lux

of light falling on an area of one square metre, one metre from the source of one lumen (Figure 3.4).

Figure 3.5 gives some rough figures for a range of typical scenes to give you an idea of the sort of numbers we are talking about. Camera manufacturers are very keen to give figures for their products to show how low a level of illumination they need. Domestic camcorders are frequently quoted as only needing between 4 and 10 lux.

Whilst it may be true that a picture can be obtained in such low levels, it is equally true that the lower the level of light, the worse the quality of picture and the worse the colour saturation will be. It is also true that the contrast level will not be high enough to get anything but a very poor representation of the scene.

In practice, the higher the level of illumination there is within a scene (provided attention is paid to the contrast range) the better the resultant picture will be in terms of colour saturation and quality. The camera, however can only deal with a certain maximum level of illumination before it saturates and the pictures 'burn out', or become too bright resulting in whiter and less well defined pictures.

A way round this can be found by adjusting the aperture setting on the lens. The aperture control is the ring on the lens barrel marked in f-numbers (2.8, 4, 5.6, 8, etc.). The aperture is an adjustable hole through which the light passes. Each move to the next highest number halves the amount of light falling on the tube or CCD, each move to the next lowest number doubles the light passing through the lens (Figure 3.6).

The aperture also has an effect on the depth of focus of the picture. Smaller numbers (f2.8, f4) will allow a smaller range

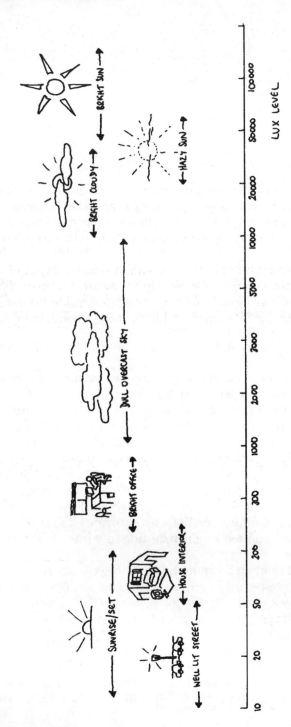

Figure 3.5 Chart of typical illumination levels of dusk, interior and exterior scene

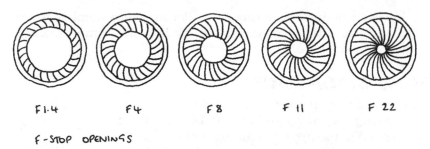

F 1.4 F 4 F 8 F 11 F 22

F - STOP OPENINGS

Figure 3.6 Relationship of aperture to amount of light being passed

(from front to back) of the scene to be in focus (Figure 3.7). Higher numbers (f11, f16) will allow a greater range to be in focus. The implications of this may give the lighting crew problems if the director requires a large depth of field in low light conditions or vice versa.

If the light cannot be reduced to obtain a smaller depth of field (outside, in bright sunlight, for example), neutral density filters can be used. These are special filters, often fitted inside the camera and selected with the ND switch, which cut the overall light down

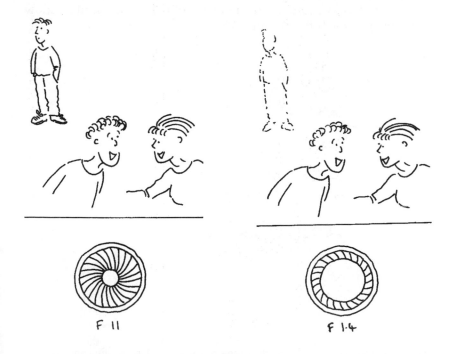

F 11 F 1.4

Figure 3.7 Effect of aperture on depth of field

by known amounts, requiring a smaller aperture number to be used to correct the light levels coming into the camera, hence reducing the depth of field.

HOW MUCH LIGHT

The light source that we are all used to is the sun. It is very bright, a very long way away and by watching the shadows, and colour, we can judge the approximate time of day.

Exterior lighting tries to mimic the sun. This involves careful placing of the lights so that not only does the brightness appear right but, more importantly, all the shadows are going in the right direction and are the right length.

Interior lighting is more tricky because there may be elements of light appearing to come through a window, or an opening door, as well as light which is supposed to come from the interior lights the set represents.

In either case we know that the camera cannot deal with the same range of contrast as our eyes. This leads the lighting person to a situation where an overall level of even lighting is required for the camera to function properly, and give good colour saturation, but still maintain the areas of brightness and shadow that our eyes perceive (Figure 3.8).

Figure 3.8 The darker areas in the scene will appear black to the camera. More light is needed in these areas so that the camera will see them

A further function of lighting must be considered when we realize that human eyes see things in three dimensions. This makes it easy to judge, for example, how far one person is from another, or how far away a background is. The camera will only see this in two dimensions, leaving lighting and control of depth of field (through aperture control) to fill in the third dimension.

One method of setting the correct light levels could be to flood the area with lots of light and then take up valuable camera time by trying to adjust it so that it looks right. This is not very scientific, or very satisfactory, and normally results in the scene looking as if it has been artificially lit (which it has).

The preferred method would be to work out how much light is needed, plot out where to put the lights and then measure the light to check the results. This will then lead to only minor adjustments being needed.

Preferred light level figures are available for cameras and it is possible to work out the approximate power requirements needed to achieve these levels. Meters are available to check the levels and colour temperature.

As a guide (Figure 3.9), a three chip CCD camera will have a typical requirement of 500 lumens per square metre and a three tube camera approximately twice this figure. This translates to a

Figure 3.9 If this acting area is 10m² then a light level of approximately 500 lumens/m² suitable for a CCD camera will need about 2,500 watts of lighting. Tube cameras will need at least twice this amount. Remember these are minimum levels

power requirement of about 250 watts per square metre for the three CCD camera and twice as much for the three tube camera.

Decisions must be taken (as will be discussed later) relating to the use of one very powerful light (as with the sun) or lots of less powerful lights (as with complex interiors) to achieve these basic levels.

The standard light meter that is fitted to most still cameras, and some video cameras, measures the light reflected back from a scene (Figure 3.10). Although they are becoming more sophisticated, with types such as centre spot or zone weighted metering, they are of little help. They cannot measure the contrast range or the colour temperature. They rely on measuring the light reflected back from a subject and work out the resulting reading based on a standard 18% reflectance figure to produce an average brightness. This works fairly well for black and white, but not all colours reflect the same amount of light giving false readings for a brightly coloured scene.

The preferred type of meter is a hand-held incident light meter. This is used by standing in the area to be measured and pointing the meter at the camera lens (Figure 3.11). The result is the

Figure 3.10 Reflected light readings are taken from the camera towards the scene. They are not sufficiently accurate for video

Figure 3.11 Incident light readings measure the light actually falling on an area. It is now possible to decide which areas will be too dark for the camera to see into

amount of light actually falling on the scene. By walking across the whole area it is possible to judge where there is insufficient light and ascertain the overall contrast range.

A good incident light meter should give a digital readout of the actual light value in lux (lumens per square metre) and follow the laid down specification for spectral response which gives the correct weighting to colour balance.

A colour temperature meter works in a similar way inasmuch as it is used as an incident meter but measures the temperature of the light falling on the scene. Due regard should be paid to the problems of mixed lighting, where it would be more accurate to point the meter at the light source (in a window area, for example).

It must also be remembered that a colour temperature meter will not produce accurate measurements with discharge light sources which not only include fluorescent sodium or mercury street lights, but also the HMI and CSI family and carbon or xenon arcs. This is because 'normal' incandescent light consists of a continuous spectrum from red to blue, whereas these special sources have what is known as a 'line' spectrum' fooling the meter

Table 3.1 Correlated colour temperature of discharge sources

Type	'Stands for'	Lumens/watt	CCT
CID	Compact Iodide Daylight	75	5500
CSI	Compact Source Iodide	90	3500-4000
Daymax	Mercury Halide Source	95	5600
GEMI	General Electric Metal Iodide	95	5600
HMI	Hydrargyrum Metal Iodide	95	5600
MEI	Metal Earth Iodide	95	5600
MSR	Medium Source Rare Earth	95	5600
SN	Tin Halide	60	5500
Xenon	Xenon Gas	40	6000

For comparison, normal tungsten lighting produces about 25 lumens/watt at 3200°K

Table 3.2 CC filters

Filter number	Colour	Temperature changed From	To	Use
201	Deep blue	3200	5600	Tungsten to daylight
202	Blue	3200	4300	Make tungsten
203	Light blue	3200	3600	light scenes
218	Pale blue	3200	3400	appear 'colder'
204	Deep orange	5600	3200	Daylight to tungsten
205	Orange	5600	3800	Make daylight scenes
223	Pale orange	5600	4600	appear warmer
236	Deep red	HMI/CSI	3200	Convert discharge
237	Red	CID	3200	source to tungsten

Standard light filter numbers have been used. Other manufacturers will have filters with different reference numbers.

into believing that it only consists of one colour.

When used as film or television lighting a mixture of different halides and gases are added to the discharge source to produce a 'correlated colour temperature' (Table 3.1). These figures can be obtained from the manufacturer and although quoted in Kelvin are only an approximation of the position the light would occupy on a Kelvin scale. These lights should be used with care because, as well as emitting 'white' light, they often emit large quantities of ultraviolet which can cause damage to the eyes and skin. Luminaire manufacturers are obliged to provide UV-absorbing safety glasses.

Where there are differences in colour temperature it is possible to use colour correction filters to convert light sources to give an overall balance. Normally the predominant light source will be used to set the white balance on the camera and then the other sources balanced to that colour. It should be remembered that placing filters in front of lights will decrease the light output and compensations may need to be made. Reference to Table 3.2 will help in deciding which filter is required. it should also be remembered that lights become extremely hot in use, only the correct fireproof filters must be attached to lights and only then by using the correct filter holder.

4
TYPES OF LUMINAIRES

Whilst sources that produce light are often called 'lights', the preferred names are lanterns or luminaires.

A luminaire will consist of (Figure 4.1) a metal case enclosing the light source, a reflector, to direct the light from the source forwards, and it may have a lens, to focus the light into a beam. There should always be some form of safety glass or wire mesh to prevent injury to performers should the light source explode. This metal casing will have some form of support, to allow the luminaire to be tilted or panned, fitted to a stand or hung from a light bar, and there will have to be adequate ventilation, so that the source does not overheat. This may take the form of forced cooling or rely on slots in the casing to allow air to flow around the lamp.

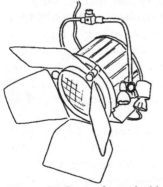

Different combinations of shapes of cases, reflectors and lenses give a range of luminaires. Each type is designed for a specific purpose and is used in a particular way. It is not sufficient to describe a luminaire as a floodlight or a spotlight.

The term 'floodlight' is used to describe the width of the beam the luminaire produces (Figure 4.2).

Figure 4.1 Parts of a typical lantern

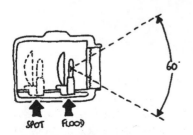
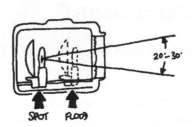

Figure 4.2 (left) Beam angles of typical flood and spot. Flood between 40°/90°, typical 60°. Spot between 20°/30°, special less than 10°

Typically this angle will be around 60°, but may be as high as 90° or as low as 40°.

The term 'spotlight' also describes the width of the beam but is much narrower. Typical widths would be between 20° and 30°, but specialist lights are available with beam angles of less than 10°. Because light intensity falls with distance as it spreads out floodlights are normally placed closer to the area to be lit than spotlights which have a narrower beam angle and, therefore, can direct more light into a narrower space.

Before we look at the range of luminaires available to the lighting team, it is worth considering the very basic function of a luminaire. The whole idea is to provide the right quantity and colour quality of illumination in order to make the scene look natural. This will involve making decisions about the type of luminaire that must be used to fulfil a particular purpose. We will consider the different types shortly.

There will be a need to plan the positioning of the lantern. In a studio this will almost inevitably mean mounting it at a height considerably above the acting area. Support systems are discussed in Chapter 5.

Once the lantern is 'out of reach', we have the problem of how to adjust its direction and angle. It is possible to specify a luminaire with one or two methods of adjustment. The simplest is to have the housing in a cradle that can be adjusted in both vertical and horizontal planes by the operator climbing up to the lantern. At the same time any adjustment of the beam size or focus can be made.

The alternative method is to specify a lantern that is 'pole operated'. With this type of housing all the adjustments to the angles and the adjustments to the luminaire beam size, type and focus are carried out by inserting a special pole into adjusting cups fitted to the lantern. This is carried out from floor level, without the need for ladders, making it quicker and safer.

LUMINAIRES

The focusing reflector

Perhaps the most well known type of luminaire is the focusing reflector light. This is the principle on which the famous 'redhead' works. Because these units are quite small and light they are favoured by location crews (there is an ENG range especially for news interview situations). They have another advantage in that they produce surprisingly high outputs. The 'focusing reflector'

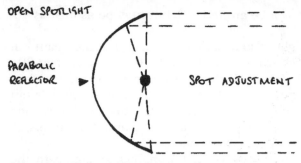

Figure 4.3 Overlapping beam patterns of redhead set to spot

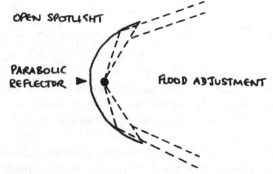

Figure 4.4 Overlapping beam patterns of redhead set to flood

name comes from the ability to focus the beam. The direct light output from the lamp will form one beam of light whilst the specially-shaped silver-coloured reflector produces another beam which is superimposed onto the direct beam. When the light source is close to the reflector (Figure 4.3) a narrow beam is produced (giving a spotlight effect), whilst moving the source further away from the reflector produces a wider beam angle (giving a floodlight effect) (Figure 4.4). The main problem with this open face type of luminaire is that it produces hard shadows, even on the so called 'floodlight' setting. There is also the need to provide a safety glass or wire mesh in case the source explodes. Not only must the safety glass be able to withstand the heat produced by the lamp, but it should also be strong enough to retain any flying particles of the lamp envelope should it explode. Proper circulation of air around the casing must be maintained.

Softlights

The true floodlight effect that we try to achieve can be seen by looking at the light from a cloudy sky. The cloud has converted

Figure 4.5 Bounced hard light. Light directed to sheet reflected back

the point source of the sun to a much larger source to produce an even, almost shadowless, light. If luminaires are to achieve this effect they must have very large reflectors. Their design means that the softer the light required the larger the luminaire must be.

Because of the need to produce an overall light level in order that the cameras can operate efficiently, we need a luminaire that produces not so much a 'floodlight' as a 'softlight'. These softlights are used to set the overall lighting level and to fill in the shadows caused by normal spotlights or floodlights. This is why they are often referred to as 'fill lights'. They are also ideal for producing an overall colour wash to a set without producing any noticeable shadows.

There are several designs that can be used to produce this diffuse and almost shadowless effect. The most obvious would be to mimic the sun behind cloud and bounce a hard source off a large white reflector, such as a sheet or an emulsioned white wall or ceiling (Figure 4.5). Essentially the source must direct light onto a diffuse matt white surface.

A typical softlight luminaire, shown in Figure 4.6, is shaped

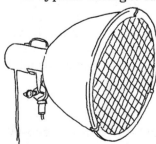

Figure 4.6 Scoop

like a megaphone and has a white interior with a special frosted light source not unlike a domestic light bulb. Because of their shape, these luminaires are often called scoops.

An alternative softlight uses a large box-like structure fitted with a number of strip lights

31

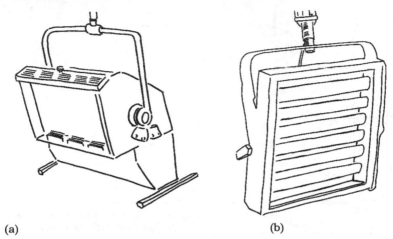

(a) (b)

Figure 4.7(a) Large softlight. (b) Large softlight with louvered opening

(Figure 4.7a). These strip lights are often wired up as pairs, allowing for control over the total light output by switching some off. Typical values would be 2.5 kW and 5 kW using four 1,250 watt linear tungsten halogen lamps with each lamp fitted into its own primary reflector to achieve an even illumination from the secondary reflector. This has the advantage of allowing the lights to run at full power and prevents a shift in colour temperature caused by dimming circuits restricting the voltage the lights are designed to operate at.

Some softlights will have a collection of small sealed-beam lights fitted inside a large reflector. One design uses as many as ten, giving rise to it being referred to as a '10 lite'.

It is also possible to buy special fluorescent tubes (often known as 'north lights') which can be grouped into a large reflector to fill in shadow areas. These use low energy electricity power and run very cool. They are based on either six 36 watt or two 36 watt tubes (Figure 4.7b).

Because it is often desirable to 'direct' the softlight beam and control the spill of light from the sides, special spill rings, or louvered openings, are normally incorporated into the front of the luminaire. These are called eggcrates.

Because of the very large forward facing area of these soft light luminaires, they are not normally fitted with a safety glass. A glass this size would need to be very thick to withstand the heat which, apart from adding to the weight of the luminaire, would cut down the overall light output. For safety reasons a wire mesh is used to catch fragments of broken bulbs.

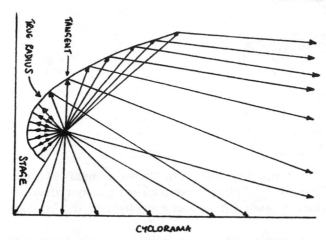

Figure 4.8 Shape of cyc reflector, with ray diagram

Cyc lights

Around the periphery of a studio is a backcloth or curtain called a cyclorama, more commonly shortened to 'cyc'. This is sometimes black in which case no light should fall onto it so that the camera sees the background as black. More commonly, particularly for light entertainment programmes, it will be coloured and needs to be lit.

Knowledge of the inverse square law will help to understand that the part of the backcloth nearest the light output (normally the top) will have a considerably higher lux level than that at the bottom which is further away from the source.

This calls for special types of luminaires, called cyc lights, to provide an even illumination from top to bottom. Figure 4.8 shows the special reflector shape used and it can be seen that the bottom of the cyc is only receiving direct light whereas further up the cyc there is more reflected light. This is a crude attempt at cheating the inverse square law and is relatively successful. For a true constant lux up the whole cyc it is necessary to use lighting from the top and the bottom.

Using these special reflector shapes and a large number of cyc lights it is possible to produce an even lighting effect where, at least, the distribution of light falls off evenly and leaves no noticeable light or dark bands.

The positioning and spacing of these luminaires is crucial if an even lighting effect is required. A typical manufacturer's recommendation is to start with the luminaires 1.5 metres from the cyc and keep the centre spacing between luminaires at 1.5 metres.

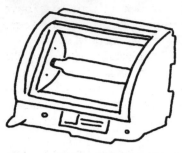

Figure 4.9 Linear tungsten bulb in single cyc lamp

These special cyc luminaires will normally use a linear tungsten halogen bulb (Figure 4.9). This provides a large light source which will help to produce a more diffuse and even lighting direct from the filament.

Although these luminaires are available singly they are normally seen in sets of four (Figure 4.10), all in one casing. This allows for colour mixing with a red, blue and green colour filter fitted to each of three and the fourth left white. This gives great flexibility if a colour wash background is required. Adding a little white light to a primary colour will desaturate the colour and help to keep the lighting more subtle and even.

Although these cyc lights are normally suspended from the grid to light the backcloth from the top, it is possible to use ground row lights (often called 'footlights', in the theatre industry) to light the backcloth or base of the set from floor level.

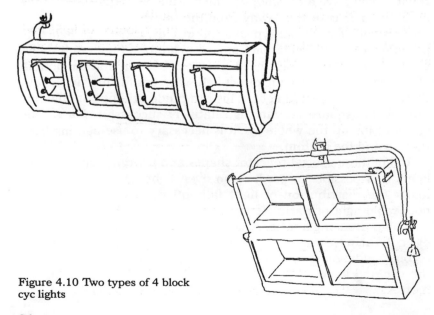

Figure 4.10 Two types of 4 block cyc lights

Some manufacturers supply a linear row of four that have special hinges to allow the whole row to be bent around the edges of the cyc, providing even illumination in the corners.

Because the position of the cyc luminaires is critical to the light distribution and it is essential that the total amount of light falling onto the cyc can be controlled, they will always be connected to dimmer circuits. It does not take a mathematical genius to realize that a very large number of dimmer circuits can be eaten up by these luminaires alone!

From a safety point of view the casings must be fitted with suitable safety glass or mesh to prevent shattered bulbs falling on the performers.

Beam lights

As we have seen the construction of luminaires is not just a question of putting a light source into a casing and pointing it in the direction we want the light to go. The science of physics is employed to produce a reflector shape which, in conjunction with a size of light source, will produce the beam shape we require for a particular purpose. It is the type and size of reflector, and its coating, together with the bulb size that will determine whether a beam is 'flood' or 'spot', hard edged or soft edged.

One of these special reflector designs uses the shape of a parabola. A parabolic reflector (Figure 4.11) is designed, as its name implies, to produce a parallel beam of light. Luminaires using this principle are known as beam lights.

If it were possible to produce a true point source of light and place it at the focal point of this parabolic reflector, a parallel beam of light would result which would be the same diameter as

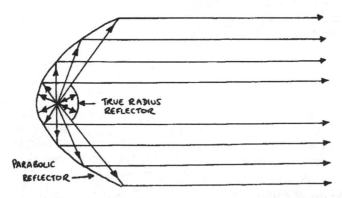

Figure 4.11 Parabolic reflector with ray figure giving near parallel beam

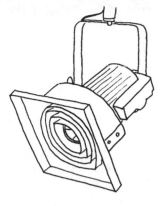

Figure 4.12 Typical beam light construction

the reflector. In practice this is not an achievable possibility, but we can get quite close.

The closest we can come to a point source is to reduce the size of the source as much as possible, this calls for the use of a very small bulb. The laws of electricity dictate that this small bulb will be most efficient if it is run from a low voltage and using a high current to produce the desired wattage. The transformer needed to convert higher (mains) voltages to these smaller voltages is normally an integral part of the light's housing.

In order to direct all the light onto the parabolic reflector, a true radius reflector is placed in front of the bulb. This prevents any direct light escaping and directs the beam into the parabolic reflector. This reflector may be a separate fitting or may be an integral part of the envelope of the lamp.

Because the light source, although small, is not a point source a beam width of about 5° to 7° is the result. With some beam lights it is possible to move the light source slightly backwards or forwards around the focal point which will give some degree of control over the width of the beam. In practice this amounts to a variation of only about 2° or 3°.

To try to keep the beam as near parallel as possible and prevent any light spilling from around the beam, spill rings are fitted inside the casing which make these luminaires very easily identifiable (Figure 4.12).

These luminaires produce high light levels in a narrow, slightly soft edged, beam at great distances from the source. A typical 500 watt model will produce around 3,000 lux at a distance of 15 metres. This makes these specialist luminaires most suitable in large venues or as a compact follow spot in smaller video light entertainment programmes.

Consideration has to be given to safety by fitting either a safety

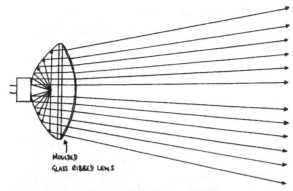

Figure 4.13 Sealed beam unit construction

glass, or fine wire mesh, to prevent pieces of damaged bulb falling out of the front of the lamp.

Sealed-beam types

So far all the luminaires we have looked at have relied on only two things. An ordinary tungsten halogen bulb, fitted into a casing, and a specially designed and coated reflector have been used to produce a particular shape of beam. No mention has been made of any type of lens placed either in front or behind the light source.

A close relation to the beam light is the sealed-beam unit. This is most commonly seen as a car headlight, but it has uses in film and video work.

The sealed-beam unit (Figure 4.13) has the same small light source and a parabolic reflector but instead of having a reflector in front of the source, to direct the light output back onto the rear parabolic reflector, it has a lens welded onto the front.

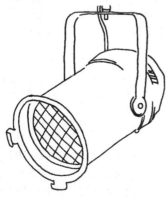

The lens, reflector and size of the unit normally produces an oval shaped beam. The most common sealed-beam units are from the PAR range, usually PAR 38 and PAR 64. The number comes from an old manufacturer's code which denotes the number being the diameter of the unit in the old imperial measure of eighths of an inch. Taking a PAR 64 as an example, 64 eighths of an inch is 8 inches making the diameter of a PAR 64 8 inches (approximately 205 millimetres).

Figure 4.14 Typical housing (Parcan or Punchlite)

Sealed-beam units come in a range of wattages and give very high light outputs. There is no need for them to be fitted into special casings but many manufacturers do produce a simple, cheap, housing allowing them to be fitted to a normal lighting grid (Figure 4.14). They are used by many small studios as sound-to-light units for pop videos.

Because the only way of controlling the beam width is by an integral, sealed, lens, manufacturers produce a range of units offering a variety of beam angles from 'flood' to 'spot'. Typically the oval beam could be from 12° by 6° up to around 25° by 60°.

To avoid complicated fittings on a simple housing, manufacturers not only produce these sealed beam units in a range of diameters and beam angles but also offer different coloured lenses as well as white.

Using a parabolic reflector effectively needs a point source of light. This means making the bulb as small as possible and we know, from looking at beam lights, that small low voltage bulbs work best. In practice the video sealed-beam units are normally supplied to work from either 250 volts or 120 volts. The 120 volt variety, apart from needing the correct voltage, offer a greater range of beam angles and higher efficiency.

With the bulb sealed inside the unit, there is not much chance of a blown filament causing any damage. However, it has been known for whole units to explode and because of this some manufacturers have a wire mesh at the front of the luminaire for protection. There is a legal requirement for the PAR 64 to be fitted with safety mesh.

The fresnel

The fresnel range of lights is the workhorse of a studio or location lighting rig. They each have a reflector, a bulb and a special lens (Figure 4.15).

We introduced the idea of a lens in front of the bulb with the sealed beam type earlier. This luminaire gets its name, 'fresnel', from the inventor of the special type of lens it uses. The 's' in fresnel is silent, so the correct pronunciation is 'frenel'.

If a normal convex lens was used it would have to be very large, making it very heavy, and liable to crack easily with the heat of the light. Fresnel discovered that if he cut an ordinary condenser lens into concentric rings, each of which formed part of the curved lens surface, and then stuck them together the resulting 'flat' lens would produce the same effect (Figure 4.16). Being lighter and thinner there is no problem with heat build up being

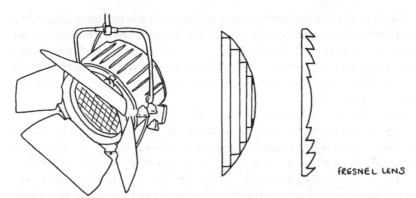

Figure 4.15 Typical fresnel

Figure 4.16 Exploded fresnel construction

dispersed through its larger surface area.

The fresnel luminaire has a part spherical reflector with the bulb placed at the centre of its radius. The resulting spread of light is condensed into a beam as it passes through the lens.

The control over the width of the beam is dependent on the position of the bulb and reflector relative to the lens. If the bulb and reflector are moved as one unit closer to the lens a wider beam angle (flood) is produced. With the reflector and bulb assembly further back from the lens a narrow (spot) beam is produced (Figure 4.17). Typically variable beam angles of between 10° and 60° are offered by manufacturers.

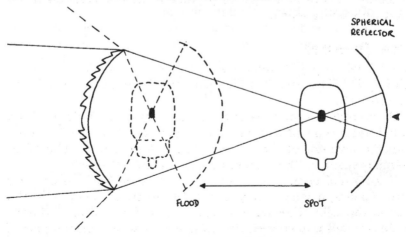

Figure 4.17 Beam angles

The fresnel is an ideal luminaire to produce the light source for the performer's soft-edged key light or back light. It is also often used to provide illumination for larger areas of a set. The perfect fresnel spotlight will have an even light intensity across the whole of its beam width, at whatever angle is being used.

The PC

Very similar to the fresnel is the PC, or plano convex, luminaire. This uses a conventional lens instead of the fresnel, but is otherwise identical in construction and performance.

Some lighting supervisors prefer the PC to the fresnel because its prime advantage is that it produces much less spill light than the fresnel and it has a better defined soft edge to the beam. The disadvantage is that some designs will have noticeable hot spots, or even darker pools of light in the middle of the beam. It is possible to minimize, but not eliminate, this effect by placing special light diffusers at the back of the lens.

Profile spotlights

'Profile spots' are not universally the same thing. The actual name will depend upon which country you work in, which lighting catalogue you look in, or how precise a description of the luminaire is used. In the USA this range tends to be called 'ellipsoidal luminaires', theatres may call them 'follow spots' or 'effects projectors'. This confusion over names is brought about by the range of uses for this particular luminaire.

The confusion derives from the complexity of the lantern (Figure 4.18). An ellipsoidal reflector is used with a light source placed at its focal point. In front of this is either a plano convex (PC) or, to reduce weight, a fresnel lens. This lens produces a beam of light that passes through a variable aperture gate, beyond which is another lens that is used to focus the beam. The result is a narrow, sharply focused, beam of light.

By altering the distance between the two lenses both the beam size and the focus are altered. The variable aperture gate consists of four shutter blades acting on the beam independently. This allows the beam to be shaped.

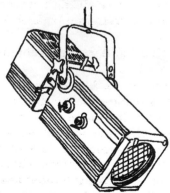

Figure 4.18 Profile

When used as a follow spot, the aperture is normally an iris, similar to that found on cameras, which can be controlled from fully open to fully shut with one lever.

Because whatever is placed in the gate can be focused, the beam can be shaped into any desired pattern. A range of commercially produced metal cut-out shapes, called gobos, are available to make the beam star shaped, keyhole shaped, triangular, etc. It is possible to buy blank gobos and make your own shapes.

It is also possible to get effects wheels that use a small motor to rotate a slide to produce effects such as fire, clouds or rain.

The main disadvantage with these luminaires is their size and weight. If a particularly narrow beam is required over a long distance it will involve a housing over a metre long. This can lead to instability of the luminaire on its mounting causing the effect to vibrate visibly, ruining the effect.

ON LOCATION

There are several reasons why luminaires designed for studio use cannot normally be used on location. 'On location' tends to mean that we are operating outside the studio in confined spaces or in the open air. This will always mean that the equipment has to be transported to the location, rigged, used, taken down and transported away. As time is money, it makes sense to have a specially designed range of lights that are light, easily transported and erected. It is possible, with major film or video productions, to hire a specially built vehicle with its own generator and lighting rig but the normal requirement is something small and portable.

For exterior locations the luminaires will inevitably have to be battery operated. This power may come from the camera or from a separate battery, but will always involve balancing how much power the battery can supply for the time required, against how much light is required.

There are three basic types of location lights: camera-mounted, hand-held or stand-mounted (Figure 4.19).

The camera-mounted variety tend to be low powered, not normally exceeding 300 watts, and provide a useful amount of frontal light, but will not illuminate all the camera can see on wider angle shots, or the background. The main advantage is the portability of the lights and the ease with which movement can be followed, making them ideal for 'reporter' situations. Kits are offered with either daylight or artificial light colour temperatures, and a range of accessories. There is, of course, a limit to what can

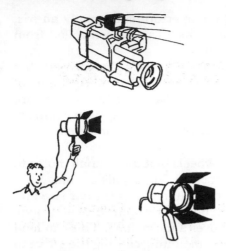

Figure 4.19 On camera and hand held lights

be done with only one light.

The hand-held variety, apart from needing an extra crew person to hold them, have the advantage of being able to be positioned at any height or angle regardless of the camera position. These lights can be larger and heavier than the on-camera variety and will provide useful illumination for a range of shots. Again, they can be matched to the prevailing colour temperature.

The stand-mounted types are more like the smaller studio lights. More normally used on mains power they offer a portable studio set up, with the more usual two or three light arrangement. The most common luminaire type in this category is the focusing reflector, discussed earlier, but there is a whole range of specially designed, daylight corrected, small fresnels.

Care is needed with location stand-mounted lights. The weight restriction often means that the stands are flimsier than normal and are easily knocked over.

5
THE LIGHTING GRID

SUPPORTS

High level

A studio lighting rig consists of either a network of metal 'bars', or scaffold pipes, arranged in a lattice pattern. This is called the grid. In some studios this is a fixed structure, but centres on an adjustable track and barrel system. Larger studios may have a system of telescopic single-point or multi-point hoists. In either case there will be the possibility to gain access to the top of the grid, for any necessary adjustments, from high level walkways. The main requirement is that luminaires can be suspended above any point on the acting area of the studio floor. Various systems are used to allow this to happen (Figure 5.1).

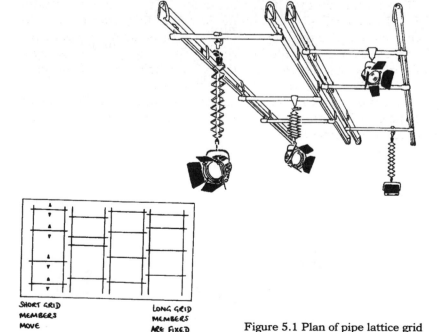

SHORT GRID
MEMBERS
MOVE

LONG GRID
MEMBERS
ARE FIXED

Figure 5.1 Plan of pipe lattice grid

Because the luminaires are suspended below the grid, the ideal height for the grid is between 3 and 4 metres, but some types of suspension will need a grid higher than this. The grid height is partly determined by the need for the luminaire to throw light onto the subject from a calculated angle (see 'Shadows and Angles 1' later), but restrictions of building and set heights will mean careful consideration of the types of supports used.

Electrical power will need to be provided at grid level and this is normally in the form of a number of sockets placed along the grid. Care must be taken to ensure that the cable to the socket is of the correct size for the lamp, which may take many amps, and that the cable from the lamp to the plug is long enough to cover the total distance that the luminaire may be extended from the socket. Remember that the luminaire could move, so its cable must allow for the furthest extremity of its travel.

It is useful if the grid has vertical bars at the edges extending to the floor. Apart from providing extra stability to the grid, the pipes running downwards provide a useful support for lights required at a lower level. Whatever type of suspension is used it is absolutely essential to observe safety procedures. The luminaire must not only be attached to its support, by the normal fixing, but additionally must have a secondary fixing which is normally a chain. The same applies to the support. The chosen support is fixed to the grid by its normal fixing and also chained as a secondary precautionary measure.

Various types of suspension are used for the luminaires. We will look first at the studio suspension mounts (Figure 5.2). The simplest mount is a C-clamp. This is a 'C' shaped fixing which is

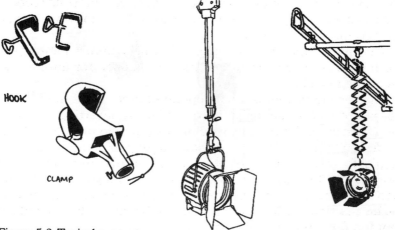

HOOK

CLAMP

Figure 5.2 Typical supports

hung and clamped, around the grid and the luminaire is fitted to its base. Normally the luminaire is chained to the grid, not the clamp. The clamp allows the luminaire to be fitted to the grid in a fixed position. The only movement possible is pivoting the lamp in a horizontal plane before fixing. A common fitting for television use consists of a hook clamp which will fit on a standard bar, into which a spigot fits. The spigot is attached to the luminaire, and allows for simple panning movement of the luminaire.

If the grid is too high for the ideal position of the luminaire an extender arm is needed. These are known as 'drop arms', 'hangers' or 'skypoles'. There are two basic types. The simplest is a pole extension, of fixed length, which is attached to the grid and the luminaire is fixed to the other end. The luminaire is clamped and chained to the drop arm, which is clamped and chained to the grid. Various lengths are obtainable. The second type is a telescopic extender. This may either be a series of sections which can be adjusted to the required length and then fixed, or it may be a telescopic or pantograph spring-balanced support which is easily altered by pulling it down, or pushing it upwards. Tension springs are used to counterbalance the weight of the luminaire. Whichever type is used it is important that the luminaire is chained to the hanger and the hanger is chained to the grid.

A much more sophisticated hanger (and much more expensive) is the pantograph. This comes in three versions which are identical except in the control over their movement. Pantographs consist of a lattice arrangement which closes to around half a metre, but can be extended downwards by as much as four or five metres. These offer a very quick method of extending a luminaire vertically over any distance within their range. Like the drop hangers, a counterbalance system is offered and both luminaire and pantograph must be chained.

The first of the three types consists of a simple pantograph which is pulled down, or pushed up, by the operator until it is at the desired height.

The second system is a pole-operated type. Here the vertical movement of the luminaire is controlled by inserting a special pole (from ground level) into a slot in the pantograph which allows winding up or down. It is also possible to get pantographs mounted on platforms, or trolleys, which will allow pole operation horizontally. Obviously if the pole-operated pantograph has a pole-operated luminaire attached to it, then the whole operation of height, position, angle and control of the beam can be carried out from the floor in a very short time.

The third system takes this a little further and is fully motorized.

Normally this will be used to adjust the pantograph to the correct position, vertically and horizontally, and then the luminaire is adjusted, but it is also possible to get motorized luminaires making the whole operation possible by remote control. Sophisticated computer controlled dimming desks are available which can control these movements remotely and store them in memory, so that they can be recalled and performed during a performance. We have come a long way from the 'let's stick a light up there' days!

Low level supports

There may be a need for luminaires to be placed at low level, in which case they will be mounted on floor stands, or tripods. It is possible that small lights will need to be placed in awkward spaces, to throw a light beam under a door for instance, which means having a mount that clips onto part of the set.

Whether on location or in the studio thought must be given to floor-mounted luminaires. Inevitably the mounting will be based on the simple tripod. Particularly on location, these are very light and unable to support great weights. There is always a problem with instability, trailing cables and the possibility of them getting in the way of cameras, microphone booms and performers. If they are used towards the back of the set, there is a need to conceal them, so they do not to appear in shot, with the added risk of fire from the heat output.

As a general rule the tripod should not extend more than two to three metres and must always be used with the legs extended as far as possible to aid stability. If it is possible to secure the tripod, by tying it to an adjacent post for example, this will add to the stability and prevent it being knocked over.

It is possible to get more substantial lantern stands that are on a wheeled base. These are preferred for studio use and offer better stability and will hold heavier lanterns. It is also possible to get short 'boom arms' to fix to the tripod, but these must always be counterbalanced and used with care. This is particularly true if it is intended that the boom arm should extend into the acting area.

Apart from tripods a whole range of useful grips and clamps are produced (Figure 5.3). Perhaps the most common for location use is a 'gaffer grip' which is like a large, strong, crocodile clip with a spigot attached for a small light. These can be conveniently clipped to window frames, exposed piping, mantelpieces and so on. They are designed only for lightweight luminaires, such as the small hand-held location lights or smaller focusing reflector types.

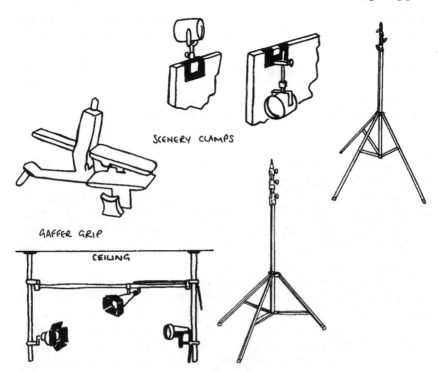

SCENERY CLAMPS

GAFFER GRIP

CEILING

Figure 5.3 Tripods, gaffer/scenery clamps

Care must be taken when using these that what they clamp to is robust enough to bear the load!

For studio use, there is a range of scenery clamps allowing small lights to be fitted either above or (with a drop arm) below scenery flats. Again safety is the rule. Although the clamp itself may be strong the heat and weight of the luminaire must be allowed for. The last thing the lighting team want to do is to cause scenery flats to fall into the acting area or catch fire.

As mentioned earlier, a whole range of possibilities is opened up if the studio grid system is extended down to floor level. Apart from adding strength to the grid system, this provides variable height suspension for luminaires that need to be clamped at low level. This is always preferable to the tripod method as there is much less chance of the lantern being knocked over, cables can be neatly concealed and tied back and the luminaire could be quite large. It gives the added advantage that conventional clamps can be used and the luminaire properly chained to the poles.

6

LIGHTING ACCESSORIES

With manufacturers offering a vast range of luminaires, it is always possible to find 'the light for the job'. What is not so easy is to find a luminaire that will do that job as precisely as we need it to. Part of the art of the lighting team is to find ways of controlling the beam width, size, shape, colour and intensity to make a video picture look right.

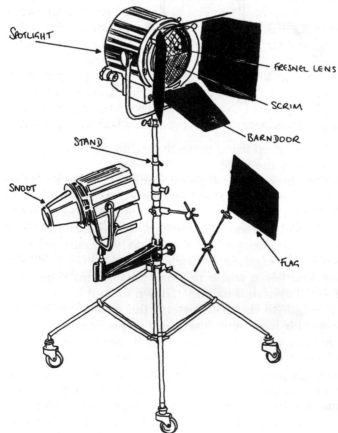

Figure 6.1 Complete range of accessories

To do this we need to employ some of the accessories that are produced to refine and customize a luminaire, so that it provides exactly the desired effect. Here we will just look at brief descriptions of the accessories available and consider the effects of fitting them to luminaires.

ACCESSORIES

Barn doors

Barn doors offer a method of restricting the beam size from luminaires. They are normally fitted to spotlights, but can be fitted to small floodlights.

Barn doors consist of a frame of four metal flaps, of which two are larger than the other two. The whole frame is inserted into a special mount at the front of the luminaire and can be rotated.

Tilting the flaps up or down (or in and out for the sideways pair) will restrict the light beam into an envelope shape of variable size. Because barn doors can be rotated they form an easy way of shaping a beam to 'fit' a particular area of the scene.

They must be safety clipped to the luminaire to prevent them falling off, and should be checked regularly to see that the hinges are still tight enough to prevent them dropping with their own weight. This can be a particularly noticeable problem when they get hot.

Snoots

Snoots are similar in principle to barn doors, in that they shape the light beam, but are pre-formed cones, of various fixed sizes. Snoots are fitted to spotlights to restrict the diameter of the beam.

Whereas barn doors give an envelope shaped beam, the snoot will allow you to provide small circles of light to highlight individual areas that are smaller than the spotlight's normal pattern. If the luminaire to background angle is reduced, it is possible to produce an ellipse-shaped beam.

Again they are fitted to the front of the luminaire and must be safety clipped, to prevent them falling off.

Flags

Flags are small opaque panels (20 cm x 30 cm is a common size, but they can be smaller or slightly larger) of thin metal, or may be large textile panels mounted in front of a luminaire. They are fitted to a short extension tube connected to a tripod on location or clipped onto the housing of the luminaire in the studio. Flags are

designed to restrict part of the light beam.

Flags will produce a much sharper shadow than barn doors and are often used to prevent light falling onto a particular object within the scene. A common problem with lighting is how to deal with a light that is in shot. Flags can be used to mask the light that is falling on the camera lens, or larger sheets of opaque cloth can be hung in front of the light (beware of heat causing fire!) to mask out a light shining from the darker parts of the scene.

For some rather unfortunate and confusing reason, flags are known in some countries as gobos. It is wiser to think of them as flags to avoid confusion with the gobos we will discuss later.

Scrims

The joys of learning a new technical language are often marred by one word meaning two totally different things! 'Scrim' is one of these words. If you want an accurate definition of a scrim it is either 'a metal screen placed in the front of a luminaire to reduce its intensity without altering colour temperature', or 'a screen, placed in front of a luminaire to act as a diffuser and often decrease the light output'.

The important thing is that, whatever else it might do, a scrim will alter the intensity of a luminaire. Scrims are placed in a holder fitted to the front of the luminaire or to a holder on barn doors or snoots. They are made of metal mesh because they are close to the source of the light and so they will get very hot.

The most effective way of reducing a luminaire's intensity is to move it further away from the scene. This doesn't affect the colour temperature (as dimming does) and any increased light spill can be contained with barn doors. On location this may not be possible because, particularly indoors, the space may not permit the luminaire to be placed exactly where you want it. This makes scrims essential to a proper lighting balance on location.

It is possible to get full-frame scrims, which will cut down the total intensity, half-frame scrims, allowing only half of the beam to be cut (these will rotate so you can choose which half), or graduated scrims, which also rotate, but allow a graded reduction in intensity from top to bottom.

If the scrim is required to diffuse the light, as well as reducing its intensity, then frosted sheets of plastic or glass fibre are placed in front of the luminaire. These must be clipped a short distance from the luminaire because otherwise the increased heat and restricted air flow can shorten the bulb life considerably.

If you have a scrim and don't know whether it diffuses as well as

cutting the intensity, a handy hint is to hold it up and look at the scene through it. If you see a clear image it will not diffuse the light.

Colours and shapes

Once we have chosen the most suitable luminaire, and adjusted its beam width, angle and shape, the next consideration is the colour of the light.

Manufacturers offer a large range of coloured gels (normally just called 'gels', originating from gelatine, the material that they used to be made from). There are well over 100 colours to choose from, some are hard solid colour, others are more subtle pastel colours used for shading. It is usual to keep around fifteen to twenty of the most often used colours in stock, but lighting directors are notorious for wanting ones that are slightly different to the more common ones for their special programme!

Gels come in rolls and are cut to fit into a special 'gel frame' that slips into a slot in front of the luminaire. They can be used in addition to barn doors, flags and other accessories. All will reduce the intensity of the light. The material used and the use it is put to will determine its useful life. Eventually the heat will cause discoloration and the gel will need replacing.

Apart from gels designed to colour a light, a complete range of gels are available for colour temperature correction. These are normally used to convert tungsten to daylight or vice versa, but it is possible to get conversion filters that are used to balance lights. Where a dimmer is used to reduce the output of a particular luminaire considerably more than the overall rig, for instance, just one light may need a slight colour temperature correction.

Fluorescent lighting, carbon arc and compact source lighting do not match the standard daylight, or tungsten, colour temperature and need to be corrected. Special glass dichroic filters are made to fit small focusing reflector luminaires, such as the Redhead range, to convert them to daylight. They are quicker to fit than gel materials.

We have said that the best way of reducing the total light intensity is to alter the light-to-subject distance and where this isn't possible we suggested the use of scrims. Neutral density gels offer a third alternative. These do not diffuse the light or affect the colour temperature, but will reduce the intensity by known amounts. A 0.3ND, for instance reduces the light by one f-stop, a 0.6ND by two f-stops.

Combination filters are made which will convert daylight to tungsten and reduce the intensity, these are useful for interior

tungsten shooting. If hung as sheets in front of a bright sunlit window it is possible to balance the light intensity and correct the colour temperature at the same time.

To complete the list of available gels, there is a range of frosts which will diffuse light, soften light and even diffuse and correct the colour temperature. Special gels will soften and tint cyc lighting, absorb ultraviolet light, or can be used to bounce light off to soften, harden or warm the overall effect. Perhaps the suggestion that fifteen to twenty need to be kept in stock now looks a little mean!

While we are looking at colours it is worth mentioning that some luminaires will accept colour wheels, or scrollers. These are motorized units which fit onto the front of the luminaire and allow a range of colours to be either 'scrolled through' at a predetermined speed, or different colours to be selected, and held, with the colour wheel movement controlled from the lighting desk as a cue.

Special luminaires, called 'effects projectors', are sometimes used in this way with special attachments to project cloud, fire or rain effects.

Two other methods are commonly used to produce specific effects, the cukaloris and the gobo. The cukaloris is commonly called a 'cookie' and is no more than a shaped piece of metal or wood that is hung in front of a luminaire. This shape, placed in the light beam, will cast a shadow in the scene. Typically they could produce shadows of trees, branches, prison bars, venetian blinds or people. Anywhere that you need a soft focused shadow all you need to do is remember how it happens in real life. Perhaps

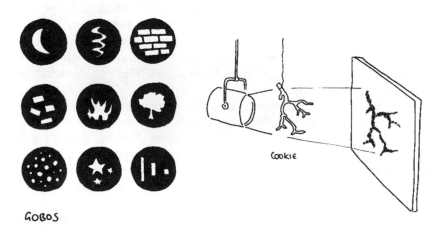

GOBOS

Figure 6.2 Gobos, cookie

sunlight filtering through a tree will throw a shadow of the tree inside a room. A cookie in the shape of a branch placed in front of a luminaire will do the same thing. A cookie is something you make, don't go out and buy it.

You may remember that when we talked about the profile, or ellipsoidal, spotlight we said that it had a gate, into which we could place slides that could be focused on the background. Metal shapes can be cut and placed in this gate. These are called gobos. We referred to the difficulties of one word meaning two things when we looked at scrims, here is another example. Some countries refer to flags as gobos, but all countries refer to the piece of metal placed in the gate of a profile spot as gobos, except the USA where they are called 'patterns'.

Gobos are used in the same way as cookies, in that they are designed to produce shapes and patterns on the background. The difference between the two is that the gobo is normally used to focus the shape onto the background. Rather than casting a shadow, it projects it.

Gobos are very useful in providing specific patterns on backgrounds and are almost always made by the lighting team from a metal stencil. Some are available, in heart or keyhole shapes for instance, but the pattern required to be projected onto the background is really programme specific, necessitating its manufacture.

7
DIMMERS AND CONTROL

The studio is a completely controllable environment. A powerful tool most studios provide is the facility to smoothly change the brightness of light, and the number of lanterns in use. This opens a wealth of possibilities for the lighting designer from the subtle, almost imperceptible, fine tuning of a lantern lighting a presenter's face turning to interview another guest, to the full scale excitement of a cabaret performance with flashing floor lights, multi-coloured backgrounds, follow spots and special smoke effects. All can be done through the lighting control system.

The principle is simple. When we plug an ordinary lantern into the mains its bulb will give the maximum output of light. Plug it, instead, into a dimmer unit and the dimmer, by changing the power fed to the lantern, can smoothly change its output brightness from fully off to fully on. To tell the dimmer unit what output power is wanted a low level control signal is fed to it from the control desk, which could be some distance away.

Each lantern is plugged into its own numbered dimmer. Often the lantern will have a large label on its support to help identify it. The numbers correspond to controls on the desk. The lighting operator, by moving fader 15, for instance, can make lantern 15 brighter or darker.

It is in the flexibility of the desk that the creativity lies. The simplest of desks may have only six faders, each controlling only one lighting channel. More complex ones will have more channels, duplicated faders (allowing lighting scenes to be preset) and switches for instant black out of individual channels or the whole output.

The most elaborate desks will have the ability to control many channels (often hundreds), to memorize lighting levels and changes, to automatically initiate fades, to allow a sound signal (e.g. music) to control lighting levels, and even control the movement and colour changes of a particular lantern. With computer technology there is enormous scope for the lighting designer who can now plan the most complex lighting effects and save all of them onto a

floppy disc to be recalled by the control desk at any time in the future.

With any lighting set up there will always be a need to control the individual intensity of each luminaire. Controlling the intensity allows the proper balancing of light in order to achieve the desired visual effect.

In television, unlike theatre, this effect can only be judged correctly when looked at on a monitor showing the camera's view of our lighting attempt. The camera and our eyes differ in their perception of contrast ratio and colour.

Location lighting will almost inevitably have to resort to altering the light-to-source distance, using scrims or using ND filters. Studio lighting, however, will have more luminaires available, a more complex rig and a fixed installation. Part of the studio lighting arrangement will include dimmer circuits and a lighting control board. The job does not become any easier, it is just done a different way.

The basic interconnection between a luminaire and its dimmer and the control desk is shown in Figure 7.1. The layout is a simple one in principle. The luminaire is connected to a socket on the lighting grid, this socket ends up as a plug that will plug into a lighting patch box, the socket on the lighting patch box goes to the dimmer which supplies varying amounts of electricity. How much electricity is available to the light, via the dimmer, is controlled by the fader circuits contained within the lighting control board.

It would be possible to connect the luminaire direct to a dimmer

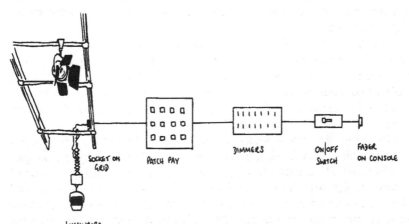

Figure 7.1 The luminaire is wired from the grid to the lighting console via the patch bay and the dimmer circuits

with a fader, but this reduces the options available if something goes wrong, like a dimmer failure. With this standard interconnection system involving sockets on the grid terminating in a patch box we have flexibility.

A combined dimmer and control pack, that will control up to four small redheads, is available for location work. This can be mounted to a special support system, giving local control over the light intensity.

With a large number of luminaires, sockets on the grid and dimmers it helps to have a simple system to identify which dimmer controls which luminaire. The normal arrangement is to have a unique number attached to the luminaire. The sockets on the grid are numbered, determined by where they are on which grid member. The plugs from these sockets are numbered on the patch box. Each socket on the patch box is marked with the dimmer number. This is shown in Figure 7.2(b), and you can see that light 12 is connected through C4 to dimmer 12.

We learnt earlier how to work out the current taken by a luminaire of a known wattage. It is essential that this knowledge is put into practice when fitting plugs, sockets, cables and dimmers together. A typical 2 kW light will take nearly 10 amps. Plugs, sockets and cables should be able to take at least that amount to prevent overheating and possible fire damage.

Often a 100% margin is allowed for cable, in this example a cable with a 20 amp rating might be used. If the luminaire was a 5 kW model it would need about 23 amps and clearly could not be plugged into the same socket or use the same cable. Dimmers are normally supplied as 5 kW or 10 kW versions, if more than one luminaire is connected to the same dimmer (typical in the

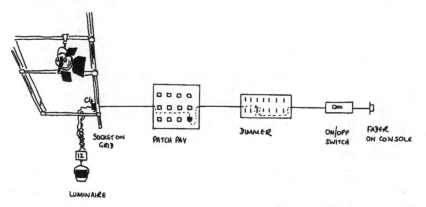

Figure 7.2 (a) Interconnection luminaire to desk

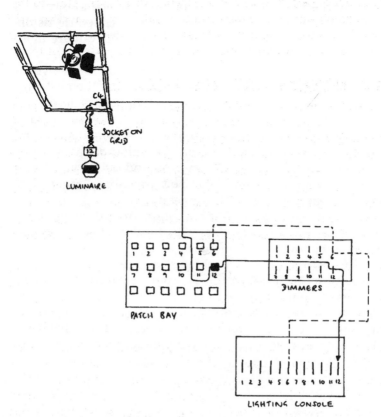

Figure 7.2 (b) The dotted line shows that C4 could be plugged into 6 on the patch bay and light 12 would then be controlled by dimmer and fader 6

case of cyc lights), a little mathematics will prevent the dimmers being put at risk.

DIMMERS

A dimmer is a device that controls the voltage fed to a luminaire. If the voltage is reduced the light source will not glow as brightly. If it does not glow as brightly it will not be at the original colour temperature. If a scene is to be shot in very low-level lighting it may well be necessary to re-do the camera white balance to prevent the camera portraying the scene as red.

Until the mid 1960s dimmers were manually operated variable resistors, which altered the voltage available to the luminaire by sharing the available voltage between themselves and the light

source. Today the majority of dimmers use a device known as a silicon controlled rectifier (SCR). These are also called thyristors or triacs. Thyristor controlled circuits are preferred, but are more expensive, because they are more stable in operation.

Within the scope of this book it is only possible to give you a rough idea of how these circuits work and to look at the problems associated with them. Basically, if a very small voltage is applied to an SCR it will 'switch on' and allow voltage to be supplied to the lamp. This very small voltage is supplied by the lighting control desk via a small fader. Depending on the value of the voltage, control circuits will switch the thyristor on and off for very short periods of time. This produces a 'chopped' waveform (Figure 7.3) and herein lies the problem with dimmer circuits.

Large electromagnetic patterns are set up around the dimmers and through the associated cabling. This can lead to interference with the audio circuits, and can cause lamp filaments to vibrate and 'sing'. Controlling these problems is expensive, involving special circuits to be fitted to the dimmer controls circuits and special cables to be used for microphones.

In January 1992, an EC directive was issued laying down regulations to control electromagnetic interference from all devices and increasingly manufacturers are paying more attention to this problem.

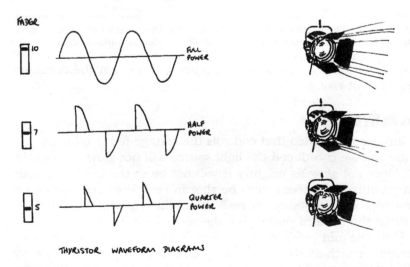

Figure 7.3 Chopped thyristor output

Dimmer systems normally work on a principle known as 'square law dimming', this means that the square of the number on the fader (marked from 0 to 10) relates to the power output of the lamp (Table 7.1), e.g. 7 on the fader represents a light at 49%, 4 on the fader represents 16%.

Table 7.1 Square law dimming

The square fader setting gives the percentage light output e.g. Fader at '6' equals light output of 36%

Fader	Light Output %	Colour Temp (K)	Mains voltage %	240	120	Current %	Power %
10	100	3200	100	240	120	100	100
9	81	3120	93	224	112	96	89
8	64	3040	88	211	106	93	82
7	49	2960	81	194	97	88	72
6	36	2860	74	178	89	85	63
5	25	2750	66	158	79	78	52
4	16	2600	59	142	71	73	43
3	9	2400	51	122	61	67	34
2	4	2200	39	94	47	59	23
1	1	-	23	55	27	46	11
0	0	0	0	0	0	0	0

The table shows the values for the operating parameters of tungsten halogen lamps when used with a square law dimming system. It should be noted that the ideal colour temperature figure is seldom reached in practice and most lamps will run about 100-200°K less throughout their range.

Table reproduced courtesy of Strand Lighting

LIGHTING CONSOLES

Since SCR dimmers became available, requiring only a small (0 to 10 volt) control voltage to make them work, it has been possible for manufacturers to make compact, but very versatile, lighting consoles allowing a range of possible control over the luminaires.

The simplest consoles consist of one fader per dimmer, only allowing each light to be faded up and down independently, the

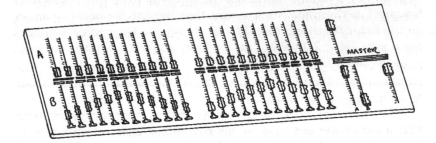

Figure 7.4 Simple one fader per channel desk

most complex are computer controlled allowing whole 'scenes' of lighting changes to be automatically triggered and stored on disc and simply loaded into the console whenever they are needed.

Manual systems have the disadvantage of needing a fader for each channel. This could mean a desk having 50 or 60 individual faders, making it quite large. Every time a light needs to be adjusted, a fader will need to be moved. Some desks will have two or more groups allowing individual lights to be set to different levels controlled by one master (group) fader. Some lighting operators still prefer this system because of the simplicity of fading up (say) channel 9 and knowing that luminaire 9 will fade up.

Memory system lighting consoles are really small computers.

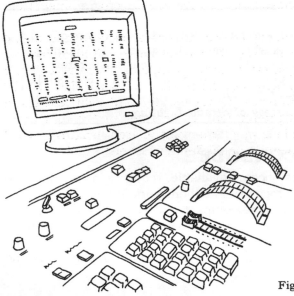

Figure 7.5 Memory desk

Instead of having one fader for one dimmer, they have one fader (which is often a wheel). Like computers there is a keyboard which allows this fader to be assigned to a dimmer. Instead of using the fader to determine the level of a light it is often possible to use the keys to enter a percentage brightness which can speed things up. Any number of dimmer settings can be entered into the memory as a cue, and recalled by calling up the memory number.

The memory is normally protected by internal batteries so that if the power fails, or the console is switched off and moved, the cues are still stored and can be recalled. Larger systems will be fully computer controlled and can store complex fade in and out information, sound-to-light instructions, cross mixes and can couple cues together.

This is helpful if a studio is used for many regular recordings using the same lighting pattern. All you need to do is set the lights once, commit it to memory, store it on disc and recall it next time it is needed. Of course the luminaires will have to be set in the right positions on the grid each time, but the levels and mixes are instantly recalled.

Because the lighting console only sends a small control voltage to the dimmers it is possible to use the console anywhere in the studio, via an extension cable. This means that the lighting director could set and adjust the lights from the studio floor before taking the console back to the lighting control area for the recording. An extension of this idea is to use a remote control handset in much the same way as a video tape recorder can be 'programmed' from a distance.

With the modern, sophisticated, control systems and digital technology it is possible to control the movement of the luminaires, as well as their brightness, from the computer. This has lead to a range of luminaires being developed that are particularly suited to pop music programmes, combining different light levels and colours with swinging movement, all operated by the computer.

We have come a long way from using different lengths of wood to try to fade up several manual dimmers at one time!

8
SINGLE-POINT LIGHTING

Over the next few sections we will look at how to build a simple system of lighting that will give exciting pictures, with good illumination and the illusion of depth and texture. We will take the very straightforward set-up of a single camera looking at a single performer, but the system we will evolve can be extended and modified to cover a wide range of scenes.

The camera must have illumination to be able to see a picture, and even for relatively sensitive CCD cameras that illumination has to be at quite a high intensity to yield a good quality image. Our eyes are both very sensitive and intelligent. We can see and discriminate detail down to very dark levels. Because our brain interprets what the eyes see we can still make pretty useful guesses about colour and texture even though we can't actually see it correctly. It can be quite misleading to use our eyes to judge the brightness of a scene to plan how we would light it. Better by far, and actually very simple, is to look at the scene we are lighting through the camera that is being used. If we arrange for its image to be on a nearby monitor we can immediately see what effect our lighting is having, and how we can improve it. Preferably this monitor should be colour, but useful information about the distribution of light and shade can be obtained from a monochrome one.

So we have set up our performer, our camera is in position, our monitor is showing what we're getting — how do we now choose what luminaire to use and where to put it? It's worth saying at this point, that however experienced you are at lighting design you can never claim that there is one correct way of lighting a particular scene. There is always scope for interpretation and, frankly, trial and error, so don't be afraid to change your lighting set-up if it doesn't seem to quite work.

On the other hand, although there is never an 'only way' of lighting a scene, a good starting point for all set-ups is to ask yourself (or your programme's director) a simple question. Where do we imagine that the light for this scene is coming from? If the scene is a prison cell with only a small high window looking out into an

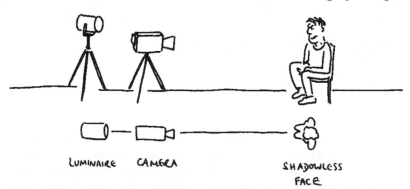

Figure 8.1 A luminaire shining along the line of a camera's lens creates no visible shadows

enclosed courtyard we would expect a different lighting set-up from a beach scene on a sunny afternoon or a moonlit graveyard. It doesn't matter that the director may never actually show a shot of the high window, or the sun beating down, or the full moon going behind the clouds — we know they are there because that's where the light (apparently) comes from.

So if we have one luminaire we might choose to put it in a position where it appears to shine from the 'natural' light's position. This at least would give a sense to where the light fell on the face of our performer. We might choose that position, but not necessarily so. In each of the examples above putting one luminaire in that position may give us unpleasantly large shadows in the performer's eye hollows and under their chin. The director may quite rightly demand to see more of the face. At least we know the starting point for where the luminaire might shine from. Now we have to do something to try and control the excessive shading.

There are two approaches to this. We can either move the luminaire so that the shadow it casts is less visible to the camera or we can choose a luminaire which gives less pronounced shadows.

Moving the luminaire will directly affect the shadows the camera can see. Because the camera picks up light from the subject, which moves in a straight line into the lens, if we shine a luminaire directly down that same line, by definition, the camera cannot see the shadows it casts. On the other hand the further away from the camera lens line the luminaire is, the more visible shadows the camera will see. Incidentally moving the performer, or the camera will have same effect as moving the luminaire, but as the director will have planned the performer's actions, and his or her camera positions we (on the lighting team) do not have that as an option (Figure 8.1).

The other option, of keeping the luminaire's position, but choosing one which gives less noticeable shadows, is perhaps safer. Perhaps now would be a good time to look in a little more detail at shadows and angles.

SHADOWS AND ANGLES 1

When we look at any scene in the natural world our eyes and brain interpret the information given by light. Without knowing exactly how, most people could tell the difference between a room in the evening, in the middle of the day, at night, even from quite poor quality photos. What we look at to get this kind of information is the distribution of the light within the image, where it appears to be coming from, and therefore where its shadows are cast. Clearly then an immensely important decision for the person designing lighting for the camera is just how to place and manipulate those shadows and angles.

Inexperienced lighting designers sometimes try to remove shadows from the images they are lighting, with the result that the shots end up bland and uninteresting. Don't forget that we expect to see shadows in the natural world. Shading gives a sense of depth. Until we get other information our brains assume darker areas to be further from us than bright ones. This simple fact allows us (as lighting designers) to re-create a feeling of depth and texture in the flat image the camera yields. Welcome shading, don't try to eliminate it, but control where it goes.

The important thing is to do what natural lighting does — give one clear defined set of shadows, but not more. There is one sun in the sky, not two, so seeing two conflicting sets of shadows on a face seems wrong.

With only one luminaire we won't have the problem of multiple shadow sets, but we do need to think about the nature of the shadows. Again a simple question should give you a hefty clue about the type of shadow you're trying to create. What is the weather like? I know this sounds a bit daft as a question for a lighting designer, but if you look at a picture of a face you can tell whether it has been taken in sunshine or under a cloudy sky by looking at the sharpness of the shadows. Sunshine casts clearly defined, focused shadows; a cloudy sky gives diffuse shadows and it is difficult to tell where they end.

In lighting terms we use the phrases 'hard light' and 'soft light' to make this distinction. We have different luminaires to give the different light types. Like sunshine hard light can give exciting vibrant pictures, but it can sometimes seem a bit too harsh. We

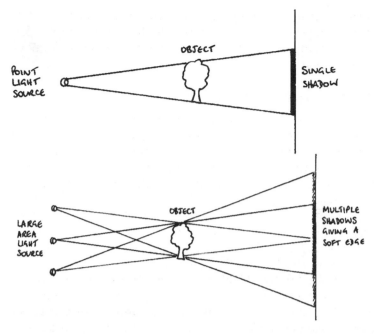

Figure 8.2 Hard light from a single point source creates focused shadows, soft light from multiple point source creates diffused shadows

need to use it with care so that we control what kind of shadows we create (Figure 8.2).

One last thought about shadows. Often they fall where we don't actually want them, and look intrusive in the image. Especially nasty is the horrible shadow on a background behind a performer. Not forgetting that we are used to one consistent set of shadows from the sun, we would quite rightly want to reduce the unsightliness of such a shadow. We have a choice. Do we want to totally remove the shadow, or do we simply want to tone it down.

The only way to eliminate it is to move one of three things, the luminaire, the performer (or whatever is casting the shadow), or the background. Moving the luminaire is self-explanatory. Moving the performer away from the background (with the permission of the director of course) will throw the shadow somewhere harmless like on the floor, out of shot. Moving the background away a short distance will also achieve the same effect (Figure 8.3).

If we want to tone down the shadow the trick is to put a wash of soft light (so it won't create more shadows) onto the background. This will dilute the intensity of the shadow. Note that simply pouring more light onto the background won't remove the shadow, and could make the background itself obtrusively bright. It's also

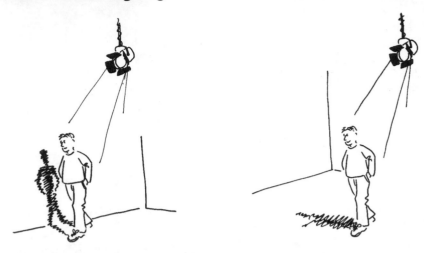

Figure 8.3 With a steeply angled light, separation reduces shadow on background

worth trying switching off, or fading down the luminaire causing the shadow — do you really need it?

This discussion about shadows links quite naturally to thinking about angles. Quite unconsciously we use information about the angle at which light is falling on a subject to interpret the circumstances. Look at six different photos of faces, you will see six different angles of light falling onto them suggesting six different times of day perhaps. We need to bear in mind these angles when planning our lighting.

Going back to the key question when choosing where to place our single luminaire — where is the imagined source of light for the scene — it becomes obvious that although we may not have an actual 'sun' in our shot we can shine a luminaire to look like the sun. This gives us an angle of shine (measured if you like against the reference of the line between camera and subject). By changing that angle we can change the apparent position of the imagined 'sun', maybe suggesting a change of time of day. By looking at the face of the performer and seeing where the shadows fall we can work backwards to where the 'sun' must be. A high noon sun will give shadows under the nose, in the eye hollows and under the chin. An evening sun will give horizontal shadows across the side of the face.

The camera doesn't see the 'sun' — it sees the effect of its angle of shine. This gives us (as lighting designers) an enormous practical bonus. With two characters in the scene, each apparently

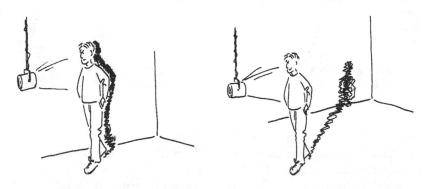

Figure 8.4 A low angle of light will cause shadow on the background wherever the performer is

lit by the same 'sun', we don't need to have only one luminaire for both of them. This would have to be quite big and quite far away to spread sufficiently. As long as there is consistency of angle of shine we could light each of them with their own luminaire, shining in parallel beams. As far as the camera is concerned they would look as though they were under the same 'sun'.

Usually we expect the 'sun' to be above us so very often the angle of shine is downward, but the steepness of the angle says a lot about the imagined conditions we are trying to create. This expected downward angle can also help us to deal with the intrusive shadow on the background. A near horizontal shining angle would throw a shadow on a background however far back it was, but if we shone downwards, a small separation would put the shadow out of harm's way (Figure 8.4).

9
TWO-POINT LIGHTING

We saw in the previous chapter how we could, ideally, place one luminaire (if that was all we were allowed) in such a position as to create the impression of light coming from an imagined 'sun' or another natural source. This could cause us some difficulty if the desirable lighting angle cast too much shadow on the subject, and we had to either compromise by changing the angle of shine, or by putting the 'sun' behind a 'cloud', or in other words using a softer light source than we might have wished. Obviously these compromises reduce the aesthetic power of our lighting design, so let's now look at what we could do if the lighting budget were doubled and we were allowed two luminaires!

The first one to set up would again be our 'sun' replica, but now we need not worry too much about the maybe harsh shadows it creates. We can choose our ideal angle, and have it as hard as we like. In fact if it is very hard we can see on the face of our subject a kind of ready reckoner of the angle by looking at where the shadow from the nose falls. At this point, whilst we are setting up that shadow will still be far too dark for the camera to see into, if the brightness of (for instance) the top of the brow is correctly exposed by the camera (Figure 9.1).

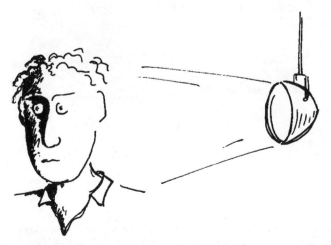

Figure 9.1 Subject lit by one hard luminaire, severe shading on face

Incidentally, camera exposure is primarily controlled by an aperture on the camera lens. This is basically a variable sized hole allowing more or less light to reach the camera's pickup devices. The scale of its operation is measured in f-numbers, and perhaps confusingly, the larger the number the smaller the hole (and therefore the less light gets in to the camera). As the sensitivity of the pickups is fixed (we cannot, as with photography or cine film, put in a faster or slower film) for a given amount of light in a scene there is only one correct aperture setting. This need not cause us, as lighting designers, too much trouble except that the aperture setting also affects how much depth of focus the camera can achieve. Depth of focus is the amount of distance towards and away from the camera where an object is in focus for a particular setting of the focus control (Figure 9.2).

The problem is that directors are perfectly entitled to ask for a particular depth of field (or f-number) to achieve the shots they want. This means that the lighting designer has to ensure correct exposure of the camera(s) by increasing or reducing the quantity of light being used on the scene. This may be achieved by judicious use of dimmers but there is a danger of inconsistent colour temperatures, so scrims and distance may have to be called in to help.

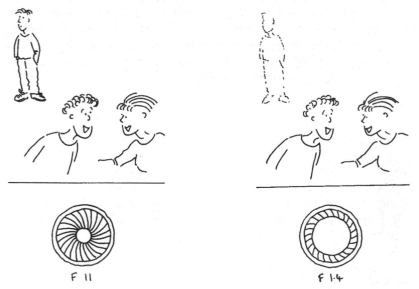

F 11 F 1.4

Figure 9.2 (a) Camera looking at scene with small aperture (large f-number) and lots of depth of field. (b) Identical set-up with large aperture and little depth of field

Anyway, we now have our subject lit by the right quantity of light to give correct exposure (with the director's chosen f number) of the bright areas of the face (brow, nose, cheek bones), but with impenetrable shadows where the first 'sun' luminaire does not shine.

Now we add the second light source. It is useful now to put some names on these lights, and we use the word 'light' rather than 'luminaire' because we are discriminating the functions of what the light does on the subject rather than the units themselves. The 'sun', in correct position to give our required angle, and with nice hard focused shadows, we will call the 'key' light. The second one we are about to add will be the 'fill' light.

So what qualities does the fill light have and where do we want it to shine from/to? The first thing to remember is that in the real world there is only one 'sun' in the sky, and only one set of shadows is visible, so we don't want our fill light to create more visible shadows on our subject. We could ensure this by pointing it straight down the camera lens line thus creating only shadows invisible to the camera. However the slightest movement of camera or subject would break that precise alignment, and result in very visible double shadows so that option is too restrictive — we are after all dealing with moving pictures of a live subject!

Better by far is to choose a luminaire which doesn't give out clear focused shadows — in other words one which gives out soft light. In the previous 'Shadows and angles' section we mentioned the difference between the two qualities of light.

Hard light comes from a single point and the beam, when broken by something, will give a sharp clear shadow. Soft light comes from many different points, so the beams crossing over in different ways give diffuse-edged shadows (see Figure 8.2). In the real world the two examples we are most familiar with are sunshine and the light from a cloudy sky. Sunshine gives clear shadows and is a hard light; a cloudy sky gives diffuse shadows and is a soft light source. It is interesting to remember though, that even sunshine is not totally hard here on Earth, since the air of the atmosphere diffuses light to a small extent. If we were designing lighting for the Moon we could then claim to have completely hard key lights.

In reality, although we discriminate between hard and soft light, there is a range of hardness (or if you prefer softness) available from production lights. We can also change the quality of them, in one direction at least. Hard light can be made softer by diffusing it. This can be done in a number of different ways, for instance by

putting a diffusing filter in front of the luminaire, or by bouncing the light off a reflector.

Coming back to the fill light and what we need it to do, it is helpful to think of the core reason for using it. Looking at our subject, with a well-placed key light shining onto him or her, our eyes will be able to see detail even in the shaded areas, but the camera won't. Correctly exposed for the bright areas, it will be unable to yield any image from the shadow parts, which will appear as dense black areas which is totally unacceptable. The fill light will lift the illumination of these areas without contradicting the shadow angle of the key light. This process is sometimes called 'contrast control' because we are using the fill to reduce the contrast ratio of the scene to bring it within the range the camera can deal with. Contrast ratio simply means the difference between bright and dark areas in the scene, and unfortunately even the best video cameras have a limited contrast ratio they can successfully render. We don't want to make the bright bits darker, so we make the dark bits brighter.

This gives us some clues about possible positions for the fill light, or perhaps positions to avoid. We obviously don't want to put it where it will emphasize the bright areas (this would also cause difficulty in holding the chosen f-number rating because we'd be increasing the quantity of light in those parts). Because it doesn't create hard shadows (which give the visual clue about the angle from which the light is coming) its actual position is not as critical as that of the key light.

Quite often the output beam from soft light sources (which we would use as fills) is very broad, so our problem is to make sure that it doesn't go where we don't want it. Taking the line between camera and subject as the base of reference, the fill light will be somewhere on the opposite side to the key light (Figure 9.3).

In some circumstances, especially where we are lighting small areas for close shots, we can achieve the necessary contrast control without an additional luminaire. We do this by using a reflector to bounce some of the light from the key back into the shaded areas of the subject. This effectively gives two angles from one luminaire, and by careful choice of reflector we can get sufficient soft light to act as a fill (Figure 9.4).

Different materials reflect the light in different ways, and alter its quality. An optical mirror would simply bend the light beam, but retain its hardness and colour quality. Other possibilities are stippled silver, white, matt white and various tones of light grey. These would increasingly soften and reduce the light. It is also

71

Figure 9.3 Camera/subject with key light, and fill light

Figure 9.4 Subject with key light from one side, reflector on other side giving soft light

possible to get reflectors which change the coloration of the light (for instance a gold coloured reflector gives a warmer looking light than silver).

Unfortunately reflectors do need to be physically quite big, and they have to be placed in the beam of the key light, so quite often they are impractical if longer shots are required. It is worth remembering however that often 'accidental' reflectors in the scene can help the lighting team. For example, a presenter's white script on the desk in front of him will help to lift the shading under his chin and in his eye hollows. On the other hand unwanted reflectance can be very troublesome — a character standing next to a green wall may look very ill from the spurious reflection back onto his or her face from the wall. Nothing is simple in video, least of all in lighting.

10
THREE-POINT LIGHTING

In the previous chapter we saw how balancing a fill light against the hard shadows cast by the key light helped to lift the shaded areas of the person to a level that the camera could see without contradicting the sense of shape and texture the shadows gave. Now if we add a third light we can achieve the nearest thing to three-dimensional pictures on a flat two-dimensional screen that is possible without extra technical trickery.

Imagine a performer wearing dark clothing, perhaps also with dark hair, against a dark background, looked at by a camera. The camera cannot discriminate between the different layers of dark tone. The black jumper combines with the black background curtains, and the black hair to form one unbroken mass of darkness. By the time this image has been processed, recorded, played back and put into a monitor, or receiver, the different blacks (which our eyes, looking directly, would be able to separate) are one solid mass. All we can see is the face, floating magically, in the midst of the black (Figure 10.1).

How can we overcome this? The solution is to use a luminaire that will put a rim of lighting emphasis around our subject to separate them from the background. This third light is placed behind the subject and it shines towards the camera position. It is called a 'back' light. With no other light its effect is dramatic.

The camera sees only the outline of the figure, plunging the face into darkness (Figure 10.2). Whilst this may be useful for

Figure 10.1

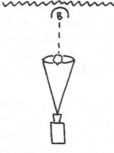

Figure 10.2

interviews with criminals or Mastermind we usually want to see more of our subject so we add this light to our key light and its balancing fill light (Figure 10.3).

Of course the camera can't see most of the light from the back light because it falls on the subject's back, but around the edge of the subject the light reflects on the surfaces of the shoulders and top of the head, and gives them an emphasized brightness. This brightness tells us, when we look at the camera's image, that there is a separate, closer layer in the scene, away from the background. It also shows that the subject is three-dimensional. Without it the camera would not be able to discriminate between a good, life-size (but flat) cut out photo and the real, live subject (Figure 10.4).

Back light should come from behind the subject!

Back light is an artificial device with no direct equivalent in natural lighting. Its function is to offer the camera an even rim of lighting emphasis around the subject, which creates an illusion of depth. Because of this its position is critical.

The back light should be as close as possible to the axis of the camera lens, beyond the subject. Too much light on one side, from behind, looks wrong (Figure 10.5). With moving cameras, multiple cameras, moving performers, or large groups it all becomes more

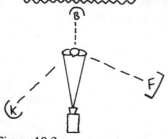

Figure 10.3

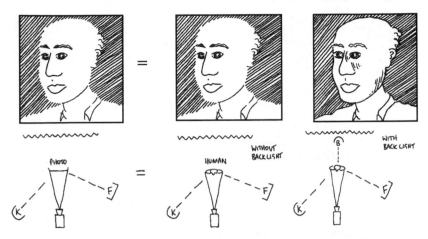

Figure 10.4

Figure 10.5

complicated, as we shall see in later chapters.

Sometimes a scene justifies an off-centre back light. For instance a character in front of a window on a sunlit evening (Figure 10.6). We see, through the camera, the sunshine streaming through

Figure 10.6

the window and that explains why one side of the character's head is brighter.

The height of a back light is also critical. Too low a back light will squirt straight into the camera's lens and ruin the shot. If it is too high the illusion will be destroyed by a bright top-of-head and darker shoulders (Figure 10.7). If it is much too high the light will creep

TOO HIGH

Figure 10.7

TOO LOW

Figure 10.8

Figure 10.9

over the top of the character's head and give them a bright nose and unsightly bright areas down over the shoulders (Figure 10.8). As is often the case in production a judicious compromise is the order of the day.

Either a hard or soft source could be used as a back light since the shadows it casts are (hopefully) invisible to the camera, but hard sources are used more often because they are more controllable. It is important that the back light does not go where you don't want it.

Back light is artificial — too much, or wrongly placed back light will ruin your scene. An excess is, briefly, glamorous — like glinting teeth and sparkling eyes — but not realistic (Figure 10.9). Like any artificial effect it should not be overused.

Use it only to separate layers with similar tone, and to give three-dimensional solidity to your images, and then very carefully, and with great subtlety!

11
PLANNING LIGHTING

As with everything else in production some organized forethought and planning will enormously help the process of getting good results from lighting.

The first stage of planning is to gather all the necessary information, the next stage is to think out what can be achieved and how best to achieve it, and the final stage is to methodically work through all the details of the plan to ensure that every possibility is catered for.

Gathering the information can be done by asking, and getting answers for, a set of questions. Some will be answered by the director, some by the lighting designer. The following list is by no means exclusive or universal, but it may provide a starting point. Naturally some answers will pose more questions!

1 Is the shoot in studio or on location?
This is a fundamental question for the lighting designer. In a studio it is possible to have completely controlled lighting. On location ambient lighting will have a significant effect.
If the answer is 'studio' go to Question 2, if 'location' go to Question 7.

STUDIO QUESTIONS

2 What equipment is already available?
Most studios will have a basic rig of luminaires and possibly some dimming or control system. It may be necessary to supplement this.

3 Is there a control system?
If there isn't already a control system it will probably be necessary to hire one for the production.

4 What lighting supports are available?
Additional lighting supports may be required.

5 Is it a saturated rig?
A saturated rig is one where there are many luminaires semi-permanently fitted. Each production simply uses its required

luminaires out of the rig. This saves enormously on the time required to specially rig luminaires.

6 What scenery is there and should it be lit?
The scenery sets the context for the shot. Whether or not it requires its own lighting or will be lit coincidentally from the performers' lighting may make a significant difference to the lighting designer's work. Usually some dedicated lighting will be necessary.

LOCATION QUESTIONS

7 What power supply is available?
A crucial question. If the answer is none the lighting must all be battery-powered (expensive) or ambient (uncontrollable) or generator (very expensive). If the answer is some but limited, the lighting must be planned within power limits. If additional power can be brought in (a special supply, or a generator) then the total capacity needs to be known so that lighting can be planned within its limits.

8 What is the weather forecast?
A cloudy sky gives blue diffuse light. A bright sun gives (slightly) redder light, bright highlights and very hard shadows. Rain, especially with thunder storms, can play havoc with a lighting plan. Snow gives enormous quantities of reflected light. Even at night the weather will give different qualities to, for instance, moonlight.

9 Which way is south?
In the northern hemisphere as the day progresses the sun moves through the sky from east to west via the south. At night, the moon does the same. Where the sun or moon is will obviously affect the balance of ambient lighting. Towards dusk or dawn significant changes in the angle and colour of light will occur. The lighting designer must be aware of these.

10 Are there any windows?
Windows let in daylight. Daylight is the big blue uncontrollable monster. Where is it going to be?

11 Will there be any ambient lighting?
Not just daylight, but any other kind of irremovable, uncontrollable light needs to be incorporated into the design of the lighting.

12 Is it a 'day for night' or 'night for day' shoot?

'Day for night' implies shooting what should be a night scene in daylight. Night time light distribution is different, and things like street lights and car headlights become significant. The camera will need special treatment, such as filters, as well. 'Night for day' is (marginally) simpler. As day is signified by large quantities of light, diffused everywhere, shooting at night to create day-like scenes (sometimes essential because of access constraints) implies a large wash of light over the whole visible scene. This is liable to be expensive!

13 What time of year is the shoot?

Think of the difference between a sunny day in December and a sunny day in July. Which does the director want? Which will be the condition when you shoot?

GENERAL QUESTIONS

14 How big is the acting area?

The size of the area to be seen on camera critically determines how many or what size luminaires you will use. Lighting a football pitch needs more luminaires than lighting the top of a coffee table.

15 How much money can be spent?

As always, the possibilities we can imagine will far outstretch the realities we can afford, so knowing the limits of the lighting budget will help the lighting designer to get the best from limited resources.

16 How many scenes are there and how do they differ?

Again a problem of planning the best use of limited resources. Luminaires which can be used on many scenes are cost-effective.

17 When is the imagined scene taking place?

If the hero kisses the heroine at lunchtime, but gets slapped on the face at dusk, there are lighting implications!

18 Where is it taking place?

If the heroine kisses the hero in the coal cellar, but slaps his face in the drawing room, there are lighting implications!

19 What lighting is assumed in the scene?

What light would you expect in a coal cellar, in a drawing room, in a haunted castle, or on a beach?

20 How many performers are there?

Each performer has to be lit to best effect and consistently. The more performers there are the more complex is the process of designing a lighting plot that will cover them all in the long shot!

21 Where do they move to?

It is fairly simple to plan lighting for a static performer. When they start to move, problems of consistency arise.

22 What camera positions are planned?

This is especially important with multi-camera shooting, since there are more cameras to worry about, but even with a single-camera shoot, different camera positions must seem (when edited together) to be continuous. An overview of all possible camera positions is essential to properly plan lighting for all of them.

23 How is the sound to be covered?

Sound is beyond the scope of this book, but it is picked up by microphones which have been known to cast shadows, so knowing the director's plan about sound is not completely useless.

24 How mobile are the camera positions?

It is fairly easy to plan ideal lighting around a fixed camera position, but if the cameras are mobile the lighting set-up must be effective for all possible camera angles. Remember that, on single camera shoots, you must plan not only for the current shot, but also for ones which will be cut adjacent to it in the final programme.

25 Are there any fire or other hazards?

Luminaires are a powerful source of heat as well as light. Electricity can cause sparks when switched on. You need to be aware of any potential fire risks when planning lighting. Remember as well that a lot of radiant heat is emitted from luminaires. This should be kept well away from objects (or people) which could be damaged.

26 Is the lighting to simply illuminate, interpret, or to add extra effects?

There is a different scale of requirement for the lighting team if the director says 'Just give me usable shots', or ' 'I want it to look like a winter morning', or 'The drum-beats must cause purple flashes on the lead vocalist'.

27 How long can we spend rigging the lights?

It is one of those laws of nature (like the toast always falling

butter side down on the carpet) that lighting takes longer to achieve than the director can spare. Having an idea of how long the director has allowed in his or her schedule for lights to be rigged will at least help you to scale the ambitiousness of what you want to achieve.

28 Are there any 'practicals'?

'Practical' lights are ones seen in the set, such as a table lamp, or car headlights. Very often these practicals can be used to add to your lighting plot, (sometimes with more powerful lamps).

29 What visual style does the programme have?

There is obviously a difference in visual style between a news programme, a cabaret show and a tragic drama. That difference will have implications for the lighting style.

30 What cameras are being used?

Different cameras have different pickup characteristics, and different acceptable contrast ratios. It is as well to know what you are lighting for.

The thinking process in the middle of planning is different for every programme, and different for every lighting designer, so it is not easy to give guidance about it here. This is the stage where your creativity and your ability to solve problems will be paramount!

The final stage is also, to an extent, a matter of personal approach, but you may find it useful to use diagrams and lighting plans to help you organize your ideas so we will take a little time to introduce you to the concepts of the lighting plan.

The basis of it is a floor plan of the shooting area. For a studio production these will probably already exist and it should be fairly simple to modify them to show where your lights will go. Each different type of luminaire should have a different symbol (Figure 11.1), so that you can distinguish them. You will need to show where the

FRESNEL SPOT

LENSLESS OPEN SPOT

FLOOD

PROFILE SPOT

CYC LIGHT OR GROUND ROW

Figure 11.1 Lighting symbols

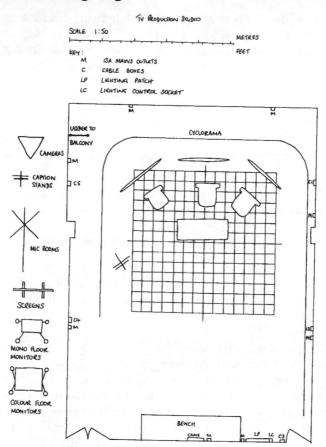

TV PRODUCTION STUDIO

SCALE 1:50

METRES
FEET

KEY:
M 13A MAINS OUTLETS
C CABLE BOXES
LP LIGHTING PATCH
LC LIGHTING CONTROL SOCKET

LADDER TO
BALCONY

CYCLORAMA

CAMERAS

CAPTION
STANDS

MIC BOOMS

SCREENS

MONO FLOOR
MONITORS

COLOUR FLOOR
MONITORS

BENCH

CAMS M M LP LC C3

Figure 11.2 Outline studio plan

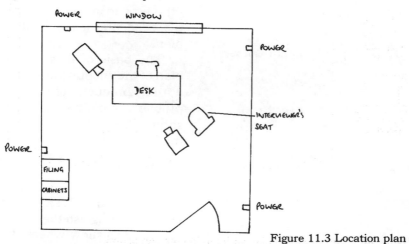

POWER WINDOW

POWER

DESK

POWER

INTERVIEWER'S
SEAT

POWER

FILING

CABINETS

POWER

Figure 11.3 Location plan

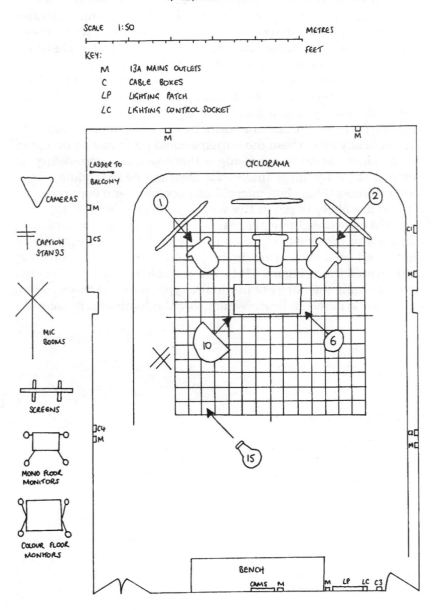

Figure 11.4 Outline studio plan with luminaires and arrows

set is (Figure 11.2).

For a location shoot it may be necessary for you to draw up outline plans of the various scenes a director is planning to use. They don't need to be too elaborate, but must show walls, doors, windows (possible sources of uncontrollable daylight) where the action is taking place, and power points (Figure 11.3).

Once you have got the basic outline plan of where the fixed points are it is probably a good idea to run off about a dozen copies of it. Onto these you can then draw different stages of the action, allowing for different camera positions and performer movements. Theoretically all of these movements could be shown on one plan, but it might get quite confusing if there was any complexity, so doing it stage by stage makes for clearer understanding. Don't forget to show things like microphone positions and floor monitors if these are likely to get in the way of your planned lighting.

Build up your lighting plan carefully, starting with the performer and camera positions, and then adding key lights, fill lights, back lights, and set lights. It might be helpful to indicate where they are powered from (Figure 11.4). It is possible to buy stencils which make drawing the different luminaire types easier. Arrows coming out of the symbols indicate which way the luminaire is pointing.

12
LIGHTING ON LOCATION

Having looked in some detail at how we might build an ideal theoretical lighting system represented by 'three-point lighting' we now move on to the problem of how to achieve that lighting, or some other design that will provide good shots, in real circumstances.

Many productions are shot on location, so let's look first at the problems of location shooting for the lighting team. Truth be told it is a rare luxury for the location team to be able to achieve 'three-point' set-ups, but they do have a base of, sometimes quite astoundingly good, natural or ambient lighting to build from.

The two main problems are too much light and too few lighting tools. These need to be addressed together, but to understand them better and move toward solutions it might be a good idea to treat them separately.

The problem of too much light centres around the fact that natural light is not where you most need it to get the best shot. Daylight is the usual culprit, and one of the main difficulties with daylight is that it changes. During the course of a day the quantity and colour temperature of daylight is constantly changing — especially if the weather happens to vary between cloudy and sunny. Although this change is often not noticeable to the naked eye, which has the intelligence of a brain to interpret it, the camera, being stupid but precise, will record the difference.

The lighting designer on location has the over-riding requirement that different shots, possibly recorded under all sorts of different ambient light conditions, must be consistent enough to cut together. The natural reaction is to suppress or eliminate daylight. Unfortunately the possibility to do this is also a rarity! How then do we control daylight so that it is beneficial rather than troublesome?

CONTROLLING DAYLIGHT
Soft or hard, cloudy or sunny, daylight indoors tends to come in large quantities, and come in horizontally, so if you can't remove

Figure 12.1 Try to orientate the camera/subject line so that you can use daylight from a window

it, it is probably a good idea to try to align the camera and subject so that the lighting direction is helpful rather than intrusive (Figure 12.1). Unfortunately that decision is down to the director (and maybe the camera operator) rather than the lighting designer. There will be decisions the lighting team can make. At the very least it should be possible to remove the difference between sunshine and cloud. Sunshine gives hard shadows, which if they're not in the right position for the shot will be intrusive. Closing venetian blinds, drawing curtains, even just putting paper or some diffusing material over direct windows will help to bring the shadows under control. Then the daylight becomes an enormous fill light, so putting the key light on the opposite side of the camera lens axis may be a good idea. Some thought will need to be given to the coloration of the light.

Daylight is not possible to eliminate outdoors, unless of course you are shooting at night! In a sense this makes it easier for the lighting designer since the main lighting plot is provided, but in reality the uncontrollability of daylight is still a problem. The real difficulty is to be able to provide matched shots from the different lighting conditions imposed by time of day and weather. Being aware of weather conditions, time of sunrise and sunset, and which way is east (and of course the other compass points) will help the lighting designer to predict how the grander lighting plan of nature is going to affect their plan. It will be necessary for the director to take advice from the lighting team about which shots (being required to cut together) must be scheduled to record together to maintain lighting continuity.

It is almost impossible on outdoors location to suppress the effect of daylight, but sometimes by judicious supplementing it is possible to take advantage of natural light. A carefully

placed soft light, for instance, may help to lift the shading caused by the sun on a performer's face, and allow it (the sun) to be used as a key light.

The key factor is the size of the shot required. If the director is working with tight close-ups it is quite easy to add to daylight with small luminaires shining into the shaded areas, maybe even a camera-top clip-on light will suffice. With the requirement for longer shots the problem becomes progressively more difficult needing bigger and more numerous supplementary lights.

It is worth discussing with the director the schedule of shots to be recorded at each set-up, particularly concentrating on the programme time of each one (to get an idea of how the imagined lighting may have evolved) since more often than not they will be required to cut together. It helps lighting continuity enormously, and cuts down on the work for the lighting team, if a basic lighting plot can be established which is usable on all the shots. This is not to say that each shot does not present particular problems, but if the foundation remains the same the problems can be solved by relatively minor adjustment, rather than a complete re-rig.

For all lighting in addition to daylight, whether indoors or out, a fundamental decision has to be made about the actual colour of the light being used. It must be consistent to avoid ghastly (and embarrassing to us lighting experts!) colour shifts in the shots, (which are virtually uncorrectable back at base). Either the daylight can be altered to fit the artificial lighting, or the artificial lighting can be adjusted to daylight colour. It is possible (but expensive) to have artificial lights which colour match daylight and this is often what the large budget professional productions use.

Realistically, it is not possible to correct all the daylight which is about outdoors to the colour of tungsten-based production lights, so the lights themselves are made bluer to match the daylight. Naturally this means some quantity loss.

Shooting indoors, especially if there are few, or small windows it may be worth considering correcting back the daylight to match the tungsten luminaires. This has the expense (and inconvenience) of having to cover all the windows with amber filter, but the advantage of balancing quantities, since the excessive daylight is reduced (by the filtering) whilst the production lights retain their full output.

Occasionally the mixture of available light can be used to advantage by a careful and subtle lighting designer. A camera white balanced for daylight, but looking at a scene with a small

amount of uncorrected tungsten light will give a warm glow to the interior. A small amount of uncorrected spill from a window on a scene set for tungsten lighting will give a cold steely look to that part of the picture. A dangerous, but sometimes successful trick!

WHAT TOOLS CAN BE USED?

The range of equipment available to the location lighting designer is enormous. At its most minimal (none at all) all the lighting person can do is learn how to operate the aperture on the camera and find the gain switch which increases the camera sensitivity at the expense of 'grainy' pictures. At the other extreme, with limitless budgets all they have to do is dream up amazing lighting rigs to be constructed and operated by the huge team of gaffers and sparks, with their generators, discharge lights, flags, gobos and brutes. Common experience is, naturally enough somewhere between these two poles.

Often they will have to try and deliver well-lit images using lights that can be carried in a suitcase. Perhaps this is counterbalanced by the fact that there will almost always be a fair quantity of ambient light which can provide the basic illumination.

Location lighting must be portable by definition. This means that the luminaires are small and robust. A very common unit is the 'redhead' — an open faced spotlight with a simple reflector and movable lamp. The body of it is made from glass reinforced plastic, which both absorbs the knocks of frequent installation and strip down and remains cool to the touch when the luminaire has been on for a while. By altering the position of the lamp the spread of the beam can be changed from spot to flood. It should be remembered though that putting the luminaire to flood does not make it soft. A bigger, more powerful version of the same principle is the 'blonde'.

Portable lighting units are often hard rather than soft, since soft lights have to be big. Hard light can be softened though, either by putting a diffuser in front of the luminaire or by bouncing the light off a large white (or reflective) surface (such as a ceiling).

Controlling the amount of light is tricky. The simplest way to reduce quantity is to move the luminaire further away from the subject, but some finesse is needed in the choice of luminaire position. Simply banging the luminaire straight onto the action may produce excessive brightness (apart from the ugly shadows). Careful change of the spot/flood control, which alters the density

of light within the beam may help to bring down a highlight. Similarly judicious re-alignment of the beam so that the action is not quite in the centre may help to reduce unwanted brightness. Who cares if the brightest part of the beam is shining where the camera isn't looking? If neither of these bring the brightness down the lighting designer may have to use wire scrims in front of the luminaire or even sheets of neutral density filter.

13
LOCATION LIGHTING — LITTLE POWER

As part of the detailed planning necessary for a production a director will undertake a 'recce' or survey of possible locations to be used. Rarely will the lighting designer be able to join the recce, so the key questions he or she will need answers to must be included in the director's check list. Apart from the obviously crucial question of what ambient lighting there is perhaps the most important one is what, if any, additional power is available.

Although it is very helpful to be able to run cameras, recorders, and monitors from mains each of these units can operate quite simply from battery power. Lighting units are power hungry so very often the limitation on lighting design is the lack of adequate power to supply lots of luminaires.

The possibilities fall into four main categories. There could be no power supply at all, a restricted supply, a plentiful supply, or (with large budgets) the possibility to bring in power supplies for the production.

With a plentiful supply, or the possibility to bring in power, the lighting team will not be hampered by that limitation, so they can concentrate on other problems. More often than not there is only a restricted supply, or none at all, so how can the lighting designer deliver good shots in such circumstances?

With no supply at all, all supplementary lighting must be battery powered. Battery-powered lighting gives independence from the mains, but because it takes a fairly large amount of current it tends to be used only with small scale shots (a close up of the interviewer for instance).

Battery-powered lights which clip onto the top of the camera and take power from a battery on the camera give the camera operator total mobility, but can have unattractive effects on the background if the camera moves, as the bright hot spot traverses across the scene.

If battery lights are required a process of calculation is essential. A 250 W luminaire will consume 20 A of current from a 12 V battery. If that battery is rated at 30 amp/hour it will last for

$1^{1}/_{2}$ hours. From fully discharged, it may then take six or seven hours to fully recharge.

The current will be used whenever the light is shining, whether the luminaire is switched on to line it up, the director is rehearsing the shot, or the shot is actually being recorded, so $1^{1}/_{2}$ hours may actually only yield 15 minutes worth of usable shot.

Bearing in mind how expensive batteries are, and how heavy to transport, the natural temptation is to economize on the number used, so the lighting designer has to ensure that such lights are used to their best ability.

Whilst some battery-powered luminaires give out more light (watt for watt) than mains-powered units most battery lights are small and can only cover relatively small areas. It would be unrealistically costly to light a large scene requiring long shots to cover it from battery power. The sensible decision would be to try to shoot the long shots under ambient lighting conditions, with some areas supplemented by battery power if necessary. Close-up shots, even though in the same scene, could effectively use battery power and could be shot when the ambient lighting was gone. This obviously requires close liaison between director (or production manager) and lighting team about the scheduling of shooting.

Battery-powered luminaires do have the great advantage of mobility, being free of cable connection back to mains. Very compact units, which can clip on to camera tops go wherever the camera goes and provide good lighting for close shots. As they are pointing almost directly down the camera lens line they don't provide modelling, but with a diffuser in front of them they can give useful fill to ambient key light sources (sunlight) which may cast uncontrollable shadows.

Their biggest disadvantage is that in circumstances where the shot opens out, or moves across a scene, their relatively narrow angle creates a visible hot spot moving over the background. We are therefore more aware of the artificiality of their light. This is great in news shooting where urgency is paramount, but not so good in drama where we want to create a consistent illusion. They can also cause difficulties with reflections off shiny surfaces behind the subject such as windows or gloss painted walls or doors.

Funnily enough this reflection makes them the ideal luminaire for one specialist purpose — that of the eye light. If you shine a fairly small light source almost directly down the camera lens line it will reflect off the surface of the performer's eyes, giving them an attractive glint or sparkle (Figure 13.1).

Figure 13.1 Camera with top light shining at presenter, light beam causing glint from the eyes

It is perhaps more controllable to use a battery-powered luminaire off camera axis. This would then provide some modelling and be usable as a key. Although they can be stand mounted many such luminaires are possible (and safe) to hand hold. This has the benefit of great mobility, but the disadvantage that it can sometimes be disconcerting to see the effect of a wobbly 'sun' as the person holding the luminaire doesn't move in exact conjunction with the camera.

A LITTLE SAFETY

Situations where there is some mains power available, but it is restricted are perhaps the commonest. Shoots taking place in ordinary homes and offices will be dependent on ordinary mains supply. This comes into the house with sufficient capacity to power cookers, electrical heating, water heaters, and the wall sockets that other items can be plugged into. Unfortunately, although the total supply may be quite large, it is divided when it enters the premises into a number of smaller capacity circuits.

Short of disconnecting the cooker or immersion heater, which (apart from the possible danger if not done by a skilled electrician) will cause enormous disruption to the normal activity of the house, no more power is available. Sometimes in a house (or office) taken over completely for the purposes of shooting (such as the houses in Brookside) it is possible to provide a large supply for production lights, but usually it is a matter of using standard wall sockets. The key concept to remember here is the idea of the 'ring main'.

A ring main is a way of sending power to a number of wall

Figure 13.2 Diagram of a simple ring main

sockets by means of two cable routes (which effectively make a large electrical ring supplying all the sockets for a particular area) (Figure 13.2). This ensures, in normal operation that the load (which may be unevenly plugged in) is balanced between the two supply cables. This ring may be capable of delivering 20 to 30 amps in total.

If it is properly installed the cables should be protected from dangerous overload by a fuse (or circuit breaker) which will cut off the supply in the event of an inadvertent overload. Considering that a 'blonde' spotlight — a fairly common 2 kW unit — will take about 8 amps, you will realize that it doesn't need many luminaires to get perilously close to the maximum capacity of the ring. If the house wiring is of a good standard and you plug in too many luminaires, the fuse will blow and you will shut off the ring main — not very popular with the rest of the crew!

If the wiring is not good (and sometimes it is difficult to judge from the external appearance) your extra luminaire may not blow the protective fuse, but instead cause the cabling to heat up dangerously with the serious risk of a fire. Although it is not desirable to get so close to catastrophe, an early warning of possible overload could be unpleasant burning smells, so a lighting team should have keen nostrils! If you do have any reason to believe something is amiss, switch off your luminaires as soon as possible.

You should be deeply suspicious where there appear to be damaged or old wall sockets, or where there are very few of them. Load up your luminaires onto the ring one by one, switching them on cumulatively, rather than all together.

If you can work out (by asking the householder, or by looking at the fuse box) which rings supply which sockets (often there is more than one ring in a house) you may be able to safely distribute your luminaire load between two or more circuits by feeding them from adjacent rooms (Figure 13.3).

Your feeder cables should be safely installed. There should be a small amount of slack cable at the foot of the light stand to allow for accidental tripping without toppling the stand. Indeed the cables must never be taut, and must never lift off the ground. Where they cross, or go along walkways they must be firmly taped down, but if possible try to find a route for them which will go over walkways — over the top of a door frame rather than across the floor. Any necessary splitting of the output of a socket should not be done by a 'Christmas tree' of adaptors in the socket, but by adequate splitter blocks fed by cable of sufficient capacity to power all the luminaires plugged into it.

Finally remember that if a fuse or circuit breaker does blow, it does so for a good reason, so you should correct what is wrong before replacing or resetting it. Do not ever defeat a breaker, or replace a fuse with one of the wrong rating (or worse with something else) to get your lights to work. That way lies certain disaster.

With all these warnings of the dire consequences of using available power supplies you may feel it is not worth all the worry, but alas, directors still want well-lit shots, so how do you provide

Figure 13.3 If you can spread your lighting load over different rings you will be less likely to overload the fuses

them with beautiful lighting? The crucial first step in designing lighting for restricted locations is to look critically at the ambient light and try to assess what it is going to do to the shot. More often than not the ambient light will have at least some natural daylight so you must also be aware of the weather and time of day.

The ambient light will almost certainly set the decision of the angle of the key light since it will be a dominant part of the lighting, and presumably the director, having chosen to shoot in such conditions, wants the effect of the natural light as a significant aspect of the shot.

Working with limited power supplies or from batteries you must ensure that all your luminaires contribute — they are a scarce resource. It is unlikely you will be able to achieve full 'three point' set-ups, and even if you do changes of sun position or cloud cover may make them unreliable. Think of the ambient light as one of your three points. Which will it do best? Bright sunlight could be the key, but it will cast such powerful shadows that you will need to add considerable fill to lift them. Diffused sunshine, or cloudy daylight could serve as a fill, but then where should you place the key? Daylight can provide backlight, but it will be so strong you will need quite bright key and fill lights to balance against it.

SHADOWS AND ANGLES 2

Let's look at examples of how each of the above combinations may work.

If you have bright sunshine, or some similar hard bright source, as an element of the ambient lighting how might you use it as a key? The first requirement is that the angle of the sun must be suitable for the camera and subject alignment. As you can't move the sun, re-orientation of the camera and subject to get the best angle is the only possibility, obviously in consultation with the director (Figure 13.4). It doesn't necessarily need a huge movement — a slight turn of the performer's head may give a much better fall of light (Figure 13.5). Be careful about previous and following shots in the programme to ensure the lighting continuity works and the eye line of the performer is appropriate.

The big problem with 'sun as a key' set-ups is the

Figure 13.4 Sunshine as line into clock face plan rotating

Figure 13.5 Head turn effect

strong shading. Here much depends on the size of shot the director wants. With a long shot you will probably have to add a softened luminaire as a fill, but with closer shots you may find it possible to use a reflector to bounce some of the plentiful sunshine back into the shadows (Figure 13.6). Remember that a silver reflector will keep the reflected light quite hard and may give unwanted double shadows, so choose instead a softening reflector (matt white or grey).

Easier perhaps to manage is the use of daylight as a fill. Naturally it would have to be softened to do this effectively, and

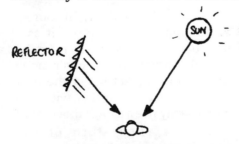

Figure 13.6 Plan of 'sun as key' plus reflector as fill

this implies that all the daylight in that shot (and therefore in that sequence of the programme) is diffuse. Partial softening of daylight is very tricky to achieve. Bearing in mind the climate in Britain, where continuous sunshine is the exception rather than the rule, softening all the daylight has practical advantage since it cuts out the possibility of a shot being ruined because the clouds come over. This decision must rest with the director. Is the sunshine a significant part of the shot or not?

Having softened the daylight the question of the angle of it arises. Once again orientation of the camera/subject line must match the angle to the available light, so unusually, we set the key angle

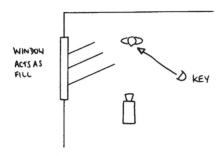

WINDOW ACTS AS FILL

KEY

Figure 13.7 Plan of window as fill plus additional key

dependent on the fill rather than the other way round. Obviously the key has to come in from opposite the approach of the fill light (Figure 13.7). Care should be taken that the new key angle is justified and not contradictory to the overall lighting distribution.

The third possibility of using natural light as one of our three points — that of back light — is the most dramatic and the most dangerous. Sunshine would be the usual source for this purpose, and it is actually a very good back light. However it poses problems of exposure for the camera, particularly in relatively longer shots.

If the camera can see areas of plane surface lit by the sun (perhaps ground in front of the performer) those planes will be very bright. To avoid over-exposing them the face of the performer would have to be under-exposed, so we need to add to it quite powerful key and fill lights (Figure 13.8).

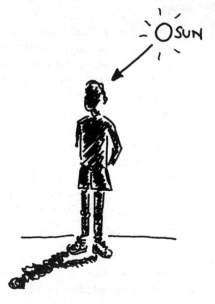

SUN

Figure 13.8 Bright sun, with a light foreground, makes exposing the performer's face difficult

97

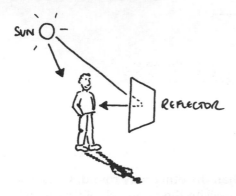

Figure 13.9 Use a silver reflector for hard light (key) — a white one for soft (fill)

One useful trick worth trying if the shot is relatively small is to have a reflector in front of the performer to bounce light back into their face. If this is silver it will maintain the hardness and could work as a key; if it is white or grey it will soften it and be the fill (Figure 13.9).

The problem with this use of natural light is the sense (or justification) of an apparent light source in front of the performer when we can see bright sunshine behind them. It could look odd.

The horrible truth is that every single location shoot poses a different set of problems which are unique to it, so there is no 'right answer' that will always work. You must be prepared to experiment.

Reassure yourself that even the most experienced lighting designers will go through a similar process — the difference will be that they may have lit similar shoots before, and so they may have some notion of what might work.

Try to get the director to give you plenty of time to set your lights. Despite their obvious need for speed, directors cannot get the best shots unless you have time to light them. Be sure to look through the camera to see what is happening as you light the scene.

It might be worth going to the location with a camera and your luminaires before the day of the shoot to try some possible solutions. Use the time whilst the director is rehearsing the shot to make final adjustments, but once he or she moves on to do takes you then cannot change your set-up, as the shots will have to cut together. Be aware as well of where these shots fit in the final programme sequence so that you can plan for lighting continuity.

14

LIGHTING IN THE STUDIO

For the lighting designer the studio is a completely controllable environment — it starts in darkness. Whilst it may not have the rare beauty of an ambient lighting basis such as, for instance, the sun setting over the sea that location lighting can sometimes achieve, it need not be dull and flat. The opportunity to use ideal luminaires, under subtle control of a dimming system gives the studio lighting team enormous scope to be creative.

The only constraint is the position of the set chosen by the director, and the resulting performer and camera positions. Sometimes even this can be influenced by the lighting team. In a studio with a permanent or saturation rig it makes good sense to build the set where the lights can most usefully get into it.

Because studio productions tend to record programmes in real time, there is often a need for a number of different lighting states within one sequence, so lighting designers must organize their use of resources carefully to achieve good results efficiently.

Let's look at a fairly typical programme type and see how the lighting might be built up. Our imagined programme is a news programme with a presenter sitting at a desk and a screen behind him or her. In another part of the studio is an interview set with two comfortable chairs and a small table (Figure 14.1). Three cameras take all the shots, with one of them moving across from the presenter to the interview set when required. Two caption stands are also used to display photos and diagrams.

The first thing to realize is that there are a number of different set-ups required for this programme and each must be treated as a separate problem. This is common with such programmes. We may be lucky and discover that one luminaire can do two functions in some parts of it. We will start by working out the lighting for the presenter.

As it is a fairly formal programme type standard three-point lighting is a good system to use. We must choose a key light position and build from there. Assuming there is no special requirement of the director to light from one side or the other we could put our

Figure 14.1 Floor plan of set

key on either side of the line from camera 1 to the presenter desk.

However there is a consequence we should be aware of now. Putting the key on the right side of the camera would entail putting its balancing fill on the left side. Whilst this would be fine for the presenter desk, it could cause us problems with spill of the fill over onto the interview set. This would not matter if the director wanted them both bright all the time, indeed it could be an advantage since the one fill may well suffice for both sets.

If the director is likely to want one set to go dark whilst the other remained bright however it would not be satisfactory, so to keep the possibility of total separation we choose the key on the left.

Another problem to bear in mind with the key position is the over shoot of it onto the screens behind the presenter. This could cause an ugly shadow, if it were only partially covering the screens. It may be possible to help alleviate the shadow by moving the screens a little further away from the presenter. If it is not we should be careful to get a steep enough angle of the key to ensure the shadow is thrown out of camera shot, without creating too steeply vertical shadows on the face of the performer. The closeness

or otherwise of the screens behind will also have a bearing on the position of the back light for the presenter. If they are too close the backlight will spill onto them — not attractive, or cut off part of the beam that should light the presenter. It may also force us to have too vertical an angle of the backlight with the danger of lighting up the presenter's nose.

Having chosen our key position we now need a fill to right of camera 1 to control the contrast. This will have the added benefit of providing an even wash of light over the background screens. We must ensure though that none of this fill spills onto the interview set.

The back light is fairly straightforward, remembering what was said above. Later when setting levels of the lights we must be especially careful that this one does not cause undue reflection from the desk top or script into camera 1. Another possibility is to have two backlights — one on each side (Figure 14.2).

Let us now look at the interview set. This is a very standard set-up with two chairs not quite directly facing each other. The reason for the slight angle is to make a more attractive shot than

Figure 14.2 Floor plan of set with three-point on main desk and two back lights

would be possible with chairs directly facing. This actually gives the lighting team an elegantly simple method of achieving three-point lighting for both performers. Looking at the plan you can see that cameras 2 and 3 are looking at each of the performers and will be able to get MCU (medium close-up) shots of them. If we take camera 2 in isolation for a moment, a key to the right of the camera would be somewhere in the section where performer B is sitting. If we put a luminaire behind B then the same light will be both key for A and back for B. A symmetrical luminaire behind A would suffice as back for A and key for B (looked at through camera 3). Thus two luminaires have done four of our six points required.

Problems may arise with this set-up if, for instance, performer B had bright shiny blonde hair and a pale coloured top on. To get sufficient brightness to adequately key A would give excessive brightness on B. This is cured by putting a half-wire scrim into the luminaire. This is a scrim that only cuts off half of the beam (the lower half) to reduce quantity in that section. With performers who are not going to move another solution would be to carefully tilt up the luminaire so that B was caught only by the lower edge of the beam, where the intensity starts to drop off.

Now we need fill light for our two performers and once again this set-up allows an economy. The dark shadows are on the sides of their faces nearest the news desk (right of A's face, left of B's face), so putting one fill central between them and shining towards the table and two chairs will deal with the shading on both (Figure 14.3).

Figure 14.3 Floor plan of set with interview set lights added

The background behind them now needs some thought. It may be covered by the fill light but may need some additional light so a row of cyc lights above the top of the background would be useful. These luminaires are designed to give an even wash of light at a very short distance. Some of these may also be useful for the screens behind the main presenter if they need separation from the desk.

The only other luminaires we need to rig are two for the caption stands. The requirement for them is exactly the opposite of modelling. We do not want to see surface texture so any shading should be deliberately suppressed by the light we use. We could use either two lights equally distanced on either side of the caption stand, or one pointing straight down the lens line. The danger with the latter is surface reflection back into the camera, but let's hope they are properly mounted matt surface captions!

We need now to start thinking about the levels of these luminaires, so let's give them numbers corresponding to dimmer channels. The real equivalent of this would be patching them into the appropriate sockets (Figure 14.4).

The first thing to do is to check that all the chosen dimmers do in fact light up the luminaires intended. Often in studios luminaires

Figure 14.4 Full light plan with cyc lights, caption lights, and dimmer numbers

are semi-permanently connected to specific dimmers, and will have large number labels on them to help identification, but if a dimmer fails, for instance, those numbers may lie! The next stage is to clearly ascertain from the director all the different lighting states required. Each one of them must then be planned, tried out, and if possible, programmed into the memory on the lighting desk to enable quick accurate recall when required.

In our hypothetical programme the director wants all the performers in silhouette while the opening music plays over the titles, then the main presenter lit whilst the interview remains in silhouette, then a smooth fade from bright presenter to bright interview set (presenter in silhouette), then both sets bright for goodbyes, then finally both in silhouette for end credits. Whew! It sounds complicated, but in reality there are a number of repeated states.

It is sensible to work them out in programme order so we'll deal with both sets in silhouette for opening titles first. Silhouette is actually very easy to achieve if you have set up full three-point lighting. If you simply bring up the back light, with little or no key or fill, the image will give you a dark front and face to the performers, with a pleasing rim of brightness around them. You may want to add just a little front lighting (perhaps from the key) to avoid it looking like an interview with a criminal, because of the totally dark face. Alternatively, if you have separate luminaires covering it you could bring up a little of the background. The balance of how much of each element is a matter for judgment by eye on a monitor.

In our scene we might have the following levels for this state:

Channel	Level	
1	25%	Presenter key, low level
3	50%	Presenter centre back light

OR

4	50%	Presenter left back light
5	50%	Presenter right back light

Optionally:

6	30%	Presenter set light
7	30%	Presenter set light
8	30%	Presenter set light
9	30%	Presenter set light
10	35%	Interview A back / B key
11	35%	Interview B back / A key

Optionally:

13	30%	Interview set light
14	30%	Interview set light
15	30%	Interview set light
16	30%	Interview set light
17	30%	Interview set light
18	30%	Interview set light
19	70%	Caption light
20	70%	Caption light

It is important to remember here that the figures for the levels, although listed as percentages, are not percentages of brightness, but are percentages of fader travel on the scale. We use this terminology because this is how most desks label it, but you will remember from the earlier technical chapters that the actual brightness of the luminaire is given by multiplying the number of tenths of fader scale by itself. Thus 70% = 7/10, gives brightness 7x7 = 49% of possible maximum brightness.

Other points to note are that the two 'cross keys' on the interview set are only at 35% because they are keys as well as backs. The background lights 6-9 and 13-18 are at 30%, but could possibly be taken right off or lifted according to the look of the pictures. The caption lights are up to their full operating level since the director may well need captions from them as part of the opening sequence. It is therefore important when rigging them that we don't allow them to spill onto either set. Seventy per cent is a normal maximum working level to cut down heat, preserve bulb life, and give the ability to control colour temperature by dimmer alteration. We assume the cameras will have been colour balanced to this lighting level.

At the end of the opening title sequence the director wants the main frontal lighting on the presenter to come up and this is our first chance to balance up a full three-point lighting set-up. What needs to happen is a very careful adjustment of the levels of the three main luminaires (together with the background lights). Work on the level of the key first, since this gives most of the illumination. We presume that the director has chosen a particular f-number to work his or her cameras at — giving a predictable depth of field. (If you don't understand this go back to page 19 where it is explained.) If not then, in a sense, we can put the lights at whatever brightness we choose and the camera exposures would have to be adjusted accordingly. However, almost certainly the cameras will

have been colour balanced for a particular dimmer setting and this should be our working maximum.

Carefully increase the brightness of the key (number 1 in our plan) whilst watching a monitor showing camera 1's picture. Pay special attention to the top of the brow, the cheek bones and the nose, as these are the first parts of the face to show over-exposure. Beware as well of bright shirt fronts, jackets, and maybe jewellery. If the dimmer ends at around 7/10 up the scale we would be content.

Now looking into the shadows cast by the key light fade up the fill light (number 2) until they are fully visible but not washed away. Be careful in case another set of shadows begins to develop on the other side of the face. Remember only one 'sun' in the sky! This may give a dimmer level slightly lower than the one for the key light, but the resultant slightly warmer coloration on that side will not be unattractive.

Finally the balance of the lighting behind the presenter needs to be set. as one of the functions of the 'back light' is to give separation from a background, it is probably a good idea to fade up the luminaires on the background first, so we can see what we are trying to separate from. Be careful here not to make it too bright. With luminaires so close it would be very easy to make the background the brightest part of the whole image, but that would be unwise. The eye tends to fall naturally towards bright areas, so if the background is very bright it will draw attention away from the presenter — not a desirable result.

Once the background level has been set, the back light can be carefully added in. Just enough to give shape and separation, not so much that the presenter is over-glamorized, should be our objective. Be aware of reflections from the desk surface or scripts thereon. The flat plane will act a little like a mirror and bounce light straight into the camera lens, giving unsightly bright areas on the desk top. It may be necessary to resort to two back lights (numbers 4 and 5).

Before we commit this lovely lighting set-up to a memory in the desk we should check whether the director is still using the caption stand lights.

So the lighting we memorize for this second lighting state, or cue, of the programme might look like this. (It should be emphasized here that the actual dimmer settings will depend on looking at the monitor showing the picture — the settings here are just examples.)

Channel	Level
1	70%
2	60% (our fill light)
3	50%
OR	
4	50%
5	50% (depending on reflections)
6	50%
7	50%
8	50%
9	50% (the background lights)
10	35%
11	35%
13	30%
14	30%
15	30%
16	30%
17	30%
18	30% (if the director wants to continue silhouette lighting the interview set; otherwise 10-18 at nil)
19	70%
20	70% (for captions still needed)

The next stage is the interview set bright, with the main presenter dropping down to silhouette again. Notice that we haven't yet worried about how to get between these various lighting cues. That will come when we have worked out what the detailed settings are for each cue.

The problem with the interview set is that our luminaires are working hard, doing two jobs — key and back — so the level setting of them is especially critical. It would be helpful to see them against the background so let's bring that up to working level of, say, 6/10 fader. Looking at the three cameras' images this will give absolutely ghastly pictures temporarily, with a bright background and very dingy performers, but we will soon transform it.

Looking at camera 2's image first, which will give us a shot of performer A, we slowly bring up luminaire 11 — A's key. As we did with luminaire 1 on the presenter, we carefully watch the brow, cheek bones and nose.

Having got it right we must now take a look at camera 3 and

performer B. For this performer, of course, luminaire 11 is a back light, and the image will look odd at the moment — partially in silhouette. We must check, though, that it is not over-exposing the rim of B that it lights. If we have been careful when rigging it (and used a half-wire scrim if necessary) it should still be reasonably balanced.

Next we go through a similar and symmetrical process to bring up the level of luminaire 10 (A's back light, and B's key light). Look carefully at each image to ensure the balance is correct between back light and key light for each performer.

Finally for this set-up we must bring in the fill — luminaire 12. Looking again at the images from cameras 2 and 3, to check that the shading on the faces of the two performers is adequately lifted. If there has been trouble getting the balance of key and back lights on the two performers, it may be worth sacrificing some modelling by reducing the level of 10 and 11 and correspondingly lifting 12 (the fill) up to maintain the illumination.

So after this adjustment we have the following as the delivered levels:

Channel	Level
1	25%
3	50%
OR	
4	50%
5	50%
6	30%
7	30%
8	30%
9	30%
10	65%
11	65%
12	70%
13	50%
14	50%
15	50%
16	50%
17	50%
18	50%
19	70%
20	70%

The last two cues required are fairly simple. Since we have already done the fine tuning on the elements of them — it is now just a question of putting different combinations together. The first is the cue where both sets are bright. This can be achieved by the following levels:

Channel	Level
1	70%
2	60%
3	50%
OR	
4	50%
5	50%
6	50%
7	50%
8	50%
9	50%
10	65%
11	65%
12	70%
13	50%
14	50%
15	50%
16	50%
17	50%
18	50%
19	70%
20	70%

The final cue is very easy as it is exactly the same as the first one. If you want to check what levels are involved go back to page 104.

The last duty the lighting team have to do to prepare the lighting for this hypothetical programme is to work out how to go between these various lighting cues. On a simple desk, with no ability to memorize, and perhaps only one set of channel faders, it will require nimble fingers, perhaps aided by a short stick, or ruler to help push a number of adjacent faders to the appropriate levels. On such desks it may be worth considering a re-patching of the luminaires to put groups which come up together to the same level, on consecutively numbered dimmers.

On slightly more elaborate desks, with more than one set of faders (called 'presets') what you do is to load the first cue into

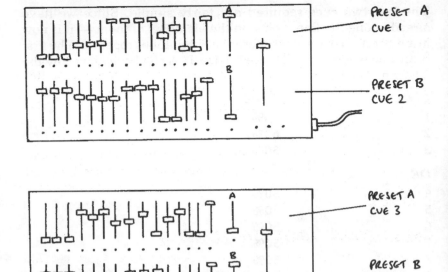

Figure 14.5 Alternate between the two presets with consecutive lighting cues

one preset, and the second into the other one. At the changeover cue you simply cross fade between the two master faders for the two presets. Then you can reload the third cue into the first preset, ready to bring it up when required (Figure 14.5).

On desks with the facility to memorize cues, the lighting operator has more to programme in at this stage, but will have a considerably easier job during rehearsals and recording.

After each of the cues it will be necessary to commit them into a memory address. Usually this is a fairly simple process of pressing a button. You may also want to store information about the speed of the changeover — called the 'profile of the fade'. You simply specify how long it will take to fade up the rising lights and how long to fade down the lowering lights and store this with the memory.

A fade taking no time at all gives a snap change between two lighting states — dramatic, but rather harsh. On the other hand, given the pace of most video programmes, a fade taking thirty seconds or longer will seem almost imperceptibly slow. Remember a lighting change required by the director is a 'seen' part of the programme, so it must be given sufficient time to be noticed. A

good working average, unless there are other specific timing requirements, is about three to five seconds.

Memory desks will often allow for automation of many of the processes involved in the fades, including the ability to initiate them automatically. This may seem tempting — programme the desk, press the button, then down to the pub! However, performers are not so predictably accurate in their timing, so to ensure the lighting changes fit correctly, the wise lighting operator will at least retain the control over when to start each fade.

The great benefit of such desks is that they allow for many more, and subtler changes, than are possible with manual desks, giving the possibility of very fluid lighting changes, repeatable with great accuracy.

SHADOWS AND ANGLES 3

In studio, with a wealth of lighting possibilities, shadows can sometimes become problematic, but are easier to deal with than on location. A common difficulty is the creation of unwanted shadows on backgrounds. Very often these can be alleviated by increasing the physical distance between performers and backgrounds. Here we benefit from the fact that any set within a studio is a total creation. We are not forced to have any particular size or shape of 'room', we can make one which will give us maximum production possibilities. Of course this decision is one taken by the designers rather than the lighting team, but a wise director, co-ordinating the work of different experts will ensure there is sufficient space in a set for good lighting.

Another frequent difficulty is that of multiple shadows, giving confused modelling. The prime cause of this is too much light, the lighting team having been seduced by the plethora of luminaires. The solution is, always, to go back to basic principles, and basic questions. Where is the one imagined 'sun', and therefore where is the one key light direction? It certainly may be necessary to have more than one luminaire serving as a key, but not more than one on each area, or performer. With the one key direction (or angle) established judicious contrast control by fills will help to tame excessive shadows.

The aspect of angles in studio is a little more complex, since one of the problems the lighting team has to deal with is the fact that each scene may be looked at by a number of different cameras, not just one. In theory a director could have cameras all around a scene, so our reference line between camera and presenter is multiplied. The trick is to look at different moments

of the programme as snapshots of time. For each moment only one camera will be active, so the lighting must be right for it. Often a compromise angle of key light angle — designed for a mid position camera — will also suffice for cameras on either side, but sometimes it may be necessary to actively change the lighting balance on a scene, depending on which camera is active. Lighting, like much else in studio, can be dynamic rather than static.

15

YOUR TURN NOW!

In the next few pages we invite you to try out your lighting skills by designing your own lighting for the scenes specified. There is a brief description of the scene and what the director wants to be lit, and also be an indication of what lighting equipment may be available, and any special factors to be allowed for.

With each exercise is a diagrammatic plan of the scene, showing camera positions, performer positions, the position of any ambient lighting and so on.

Try to think out how you would approach the lighting of the scene. You can do this as a simply imagined exercise, or you might like to pencil your solution onto the plan, or perhaps you want to build up the scene and try to light it for real!

Once you have done your best, look at the suggestions on how we might do it, which follow after Exercise 4. We should stress here that there is never only one correct answer, least of all the one we suggest. You may well come up with a better way of solving the problem. On the 'Possible Solution' pages, there is room for you to make your own notes.

EXERCISE 1: LOCATION INTERIOR

For a documentary the director wants an interview with the manager of a local water plant in his office which overlooks the works. The main part of it will be shot with him at his desk in front of the window. He insists he can only make his office available for an hour and doesn't want anything moved in it. The director plans to get MCUs and MSs of him at his desk, reverse angle MCUs of the interviewer for 'noddies', an LS from the door of the interviewer entering the office and being greeted, and possibly some shots showing the manager standing at the window indicating parts of the plant.

The window faces south, and the weather is forecast to be overcast. There are plenty of power points in the room and the corridor outside it. The walls of the office are painted cream and the ceiling is white. The window has a venetian blind. The desk has a glass top. The room has fluorescent lighting, with a small tungsten desk lamp.

EQUIPMENT AVAILABLE INCLUDES:

- 2 x 2 kW 'blonde' lanterns, with stands
- 3 x 800 W 'redhead' lanterns, with stands and gaffer clamps
- Plenty of blue daylight correction filter
- Some amber tungsten correction filter
- A little diffusion material.

Exercise 1: Set — location interior

EXERCISE 2: STUDIO INFORMATION PROGRAMME

A studio based information programme, with one presenter, is being recorded. The elements of it include the presenter sitting in a comfortable chair, talking to camera and describing video clips, the presenter walking across to another set, which has a table of artefacts, close-up shots of those artefacts, photographs and diagrammatic captions, on two stands, and a large programme logo on the back wall of the set.

The director wants the presenter to be seen first in silhouette, with the logo visible, in long shot. A similar shot will be used at the end under the credits. The captions are needed all through the programme.

EQUIPMENT AVAILABLE INCLUDES:

* 8 x 2 kW fresnel spots
* 2 x 1 kW fresnel spots
* 6 x 1.25/2.5 kW floods
* 2 x 2 kW profile spots
* 32 cells of cyclorama lights (500 W each) in clusters of four
 [All the above are riggable anywhere, at any height.]
* A 2-preset 24 channel (2.5 kW capacity per channel)dimming system
* No floor stands

Exercise 2: Set — studio information programme

EXERCISE 3: LOCATION EXTERIOR

A ceremony is about to take place! The local cinema has arranged for a splash preview of a famous film, together with guest appearances by celebrity stars of the film. The local cable TV station want coverage of it. The stars will arrive by limousine at 8 pm and walk up the red carpet to the entrance of the cinema. Inside they will be greeted by the cinema manager and the mayor. Inside the cinema there is a large foyer, with an overlooking balcony (closed to public and guests). Opposite the cinema, across the road, access is possible to a shop and the flat above it. There is expected to be a large crowd outside the cinema, but they will be behind barriers. There will also be a (fairly famous) interviewer who is detailed to ask questions of the stars as they leave their cars.

The event is to be covered by four camera units. The two outside will have microwave links back to a control van. They will deal with the long shot of the cinema front (from the shop opposite) and the 'out-of-car' interviews. Inside the cinema will be two more, one down in the foyer to grab shots of the great and good as they mingle, the other on the balcony to get long shots. There is plenty of power available in the cinema and in the shop opposite, but the local council's health inspector has insisted on no mains powered lights at ground level outside the building and is concerned about safety aspects inside the cinema foyer.

By the way, the cinema has illumination of its frontage, which will be on, and the event is taking place in February. The weather forecast is for dry, but cold weather. The local cable station, running a volunteer programme, has plenty of people available to crew this event.

The equipment available has not been finalized since the station's lighting director has been taken ill. You have been asked to take over, 24 hours ahead of the programme, and you have been told, that within reason, you can hire whatever you need. What would you order?

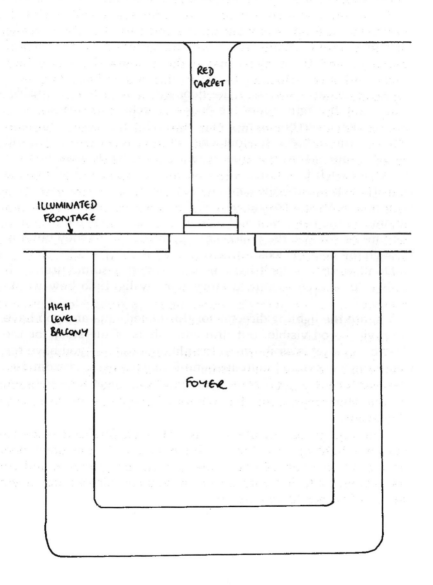

SHOP + FLAT

ROAD

RED CARPET

ILLUMINATED FRONTAGE

HIGH LEVEL BALCONY

FOYER

Exercise 3: Exterior location

117

EXERCISE 4: DRAMA IN STUDIO

A suspicious character leans against a lamppost outside a doorway. Inside the weary manager checks the last couple of cases in the corner of the dingy warehouse then puts his clipboard on top of one of them, scratches his forehead, and moves towards the door, feeling in his pocket for his keys. As he opens the door the character lurking outside melts further into the shadows, and the bright stream of light cascades across the pathway.

The manager — outside the door by now — reaches inside, switches off the light, closes the door and locks it. He steps across the pavement, but before he can go a couple of steps he is brutally struck down by the suspicious character who steals his key and quietly re-opens the door. The manager is left for dead as the thief strikes a match to orient himself in the warehouse. Rapidly the light from the match dies out, but by now the thief's eyes have grown accustomed to the moonlight streaming in through the window on the back wall and he can see his way to the top case. Too late he realizes the police have arrived, and as they burst in through the door his look is one of desperation.

Don't worry — don't have nightmares, it is studio drama. It is also, to a large extent, a story told by light, so how would you do it?

You are the lighting director for this melodrama and you have to provide good visible, but dramatic, shots of the story for the director. The set is as shown in the plan opposite — you have the usual range of studio luminaires and fittings to use and a dimmer system with memory. There is a moderate budget for additional lighting equipment should you need it.

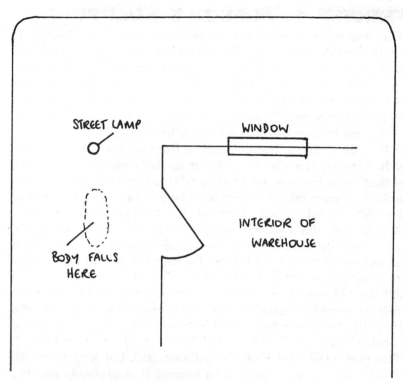

STREET LAMP

WINDOW

INTERIOR OF
WAREHOUSE

BODY FALLS
HERE

Exercise 4: Studio set

EXERCISE 1: POSSIBLE SOLUTION

Perhaps the main difficulty here is the imposition of the window. It will be a very bright light source. Thankfully the weather is due to be overcast so we can assume fairly constant colour temperature. Because the director may require a shot of the manager looking out of the window we cannot simply over-expose the outside to bring up the relative brightness of the interior. Nor can we close the venetian blind. We must therefore lift the interior brightness.

A heavily diffused 'blonde' shining from by the filing cabinets may help to lift the overall ambient in the room to a sufficient level that it can balance the daylight. If this is not enough a second 'blonde' bouncing off the ceiling may help. The pale walls should help to diffuse and maintain the level, but may be tricky for colour.

A 'redhead', shining from between the camera and interviewer, or from the right of the interviewer could work as a key, on top of the increased ambient achieved by the 'blonde(s)'. For the reverse shots it would have to be removed.

All the lanterns would have be corrected back with blue filter, or, less preferable because of the requirement to see out of the window, the window could be corrected with amber, and the lanterns left open.

The glass desk top could be problematic, but as long as we don't use an additional back light behind it is probably one the camera operator will have to deal with. The desk lamp, especially if the manager has white papers on his desk, could provide some useful contrast control under his chin and provide a local source of brightness which will help balance the excessive brightness of the window in the shot. Whether or not to colour correct it is a matter of judgment depending on the look of the picture — it could be quite nice set at 'wrong' colour giving a warmth to the desk area.

- What would you do if you didn't have (or couldn't power up) the 'blondes'?
- What would you do if the weather forecast was for sunshine and showers?
- What would you do if the interview was to be shot at night?

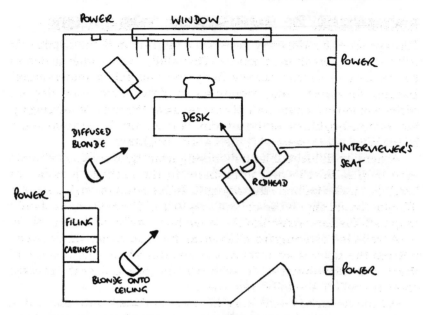

POWER WINDOW POWER

DIFFUSED
BLONDE

DESK

INTERVIEWER'S
SEAT

POWER

REDHEAD

FILING

CABINETS

BLONDE ONTO
CEILING

POWER

Exercise 1: Possible solution

NOTES:

EXERCISE 2: POSSIBLE SOLUTION

The presenter in her chair could be lit by 2 kW fresnel spots as back and key (1 and 2) and a flood as fill (3). For the silhouette the fill and key would be reduced in level. In the position behind the table again 2 kW fresnels (4 and 5) could be used, but carefully barndoored down to avoid spill onto the table itself. It is possible that the fill for the seated position may also cover this area — if not a similar one (6) could be used.

The walk could be adequately covered by the soft light from the fills, if it is reasonably quick, and seen only in long shot. Otherwise use an additional key — again a 2 kW fresnel (7). Care should be taken in this case to accurately barndoor the beams of the three keys down so that they don't overlap, or leave black holes. All three keys should be steep enough to avoid spill onto the cyclorama.

The objects on the table could look very good given edge lighting from each end of the table. This could be adequately done by the two 1 kW fresnels (8 and 9). The caption stands need separate luminaires — a couple of 2 kW fresnels would do (10 and 11). Again care should be taken to avoid unwanted spill from these. The logo can be lit by a single spot. A 2 kW spot will do and the profile type has the advantage of being sharply controllable at the edge.

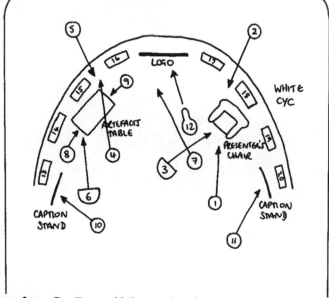

Exercise 2: Possible solution

Finally the cyclorama can be lit by the 32 cells of cyc lights, patched in groups. Normally these are coloured up red, green, blue and open white, patched so that each colour is on a separate dimmer (or dimmers). It is then possible to blend the colours to achieve a wash of any desired colour (13-20).

NOTES:

EXERCISE 3: POSSIBLE SOLUTION

This is quite a challenge, especially as there are going to be lots of people about and it is a 'one chance' shoot. Actually though it is quite straightforward. The good news is that because of the nature of the event, simply getting well illuminated images will suffice; we do not need to worry about the niceties of three point, modelling, contrast control, etc. Because it is February (at 8 pm) we have no intrusive daylight to worry about and because the weather is forecast to be dry, problems of rain into hot luminaires should not arise. There is a little worry about the council's health and safety inspector though, so we should be careful not only to be safe, but to be seen to be safe.

Deal with outside shots first. The frontage will be bright but with badly distributed light (mostly on signboards, etc.). We would like a wash over the whole of it so a couple (maybe one if it's big) of luminaires in the flat above the shop opposite would be helpful. The temptation here is to go for something like a couple of HMI 1200 W spots, which would give a huge light output, but if they are not available two 'blondes' might do the job.

The 'out-of-car' interviews grabbed by the famous interviewer obviously need highly mobile lighting, so battery-powered camera top lights are essential here. They could be usefully added to by separate hand-held 'sun gun' lights operated by some of the many spare crew.

Inside the health inspector would be happy if there were no luminaires anywhere in the public areas, so putting them on the balcony seems a good idea. This also serves our purpose, of getting them well out of the way of possible knocking over by the throng. As different cameras are covering inside and outside shots we don't have to worry about lights shining into the lens of cameras coming through the door so putting a 2 kW 'blonde' on each corner of the balcony should give us good coverage. To avoid possible crossed shadows it might be worth diffusing the luminaires on one side.

NOTES:

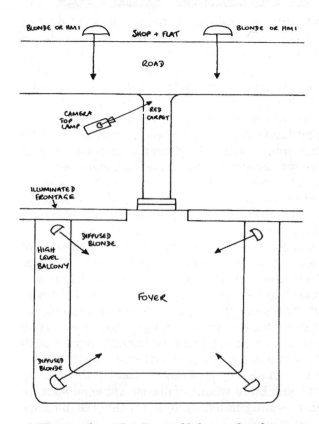

BLONDE OR HMI
SHOP + FLAT
BLONDE OR HMI
ROAD
CAMERA TOP LAMP
RED CARPET
ILLUMINATED FRONTAGE
DIFFUSED BLONDE
HIGH LEVEL BALCONY
FOYER
DIFFUSED BLONDE
DIFFUSED BLONDE

Exercise 3: Possible solution

EXERCISE 4: POSSIBLE SOLUTION

The interesting challenge of this is that there is a great deal of atmospheric lighting required, but with next to no chance of standard three-point lighting. It needs to be dealt with stage by stage.

The first thing to think about is our suspicious character leaning against a lamppost.

The crucial clue is the lamppost. Think of how light falls from streetlights — pools of localized, vertical light. So what we need here is a single spot shining directly down onto our character. Whilst it is quite acceptable for the streets to look dark at night, we may wish to give our cameras the chance to pick up some details when the character is first seen, so a little soft light wash added on to the spot may be useful. This light could creep down as we become more used to him being there.

Inside the manager is working under artificial lighting, so again we would expect its shadows to be nearly vertical. Whilst the overall ambience is higher than out on the dark street, it still doesn't crawl very far up the walls and is very localized. Maybe some small amount of soft light might be helpful to lift it.

When he opens the door the stream of light from inside may well need its own spot, at low height, shining horizontally through the door opening.

Once he is outside, there is a special requirement of the lighting to emphasize his stricken body when it falls, so a special spot for this is necessary, to be subtly faded up to a low level as he falls. Otherwise it is a repeat of the first scene — use of illuminating soft dependent on the needs of the story.

Inside the building, the thief striking a match is purely a practical (done by the actor) but it gives us the chance to cheat in a little ambient soft lighting to see what happens. The moonlight is dead simple. We think of it as blue, although it isn't particularly, and when visible it is very hard. If it happens to cast a shadow of the window frame (gobo in a profile spot) even better.

The approaching police car is a rhythmically flashing primary blue light outside the window, mobile if possible. Thought now needs to be given to the timing of the changeovers, and luckily we have a memory desk which will greatly simplify the accurate repeat of them. The creep down of the exterior soft light (to see details of the thief) would be a 30 second slow fade. The door opening has a luminaire switched on (a zero time fade), followed shortly by it (and the interior lighting set-up) switching off. The

spot for the fallen manager needs to come on (but not very bright) as he falls, so that is also quick, maybe $1\frac{1}{2}$ seconds.

The time of the match burning can allow us to creep up enough soft light to see what he's up to inside (maybe 10 seconds).

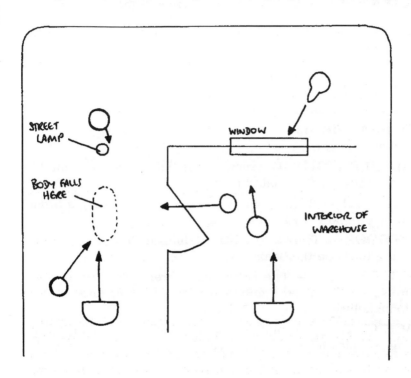

Exercise 4: Possible solution

NOTES:

GLOSSARY

AMBIENT LIGHT — The existing light before any supplementary light is added.

AMP — (Ampere, A) The unit of electrical current. Small (1 kW) lights use nearly 5 amps. Larger (3 kW) lights use 15 amps.

APERTURE — The variable-sized opening in a lens that controls the amount of light passing through the lens. Large apertures have small f-numbers, small apertures have large f-numbers.

ARTIFICIAL LIGHT — Light that is produced by any source other than sunlight.

AVAILABLE LIGHT — Existing light that is deemed suitable to produce reasonable quality pictures.

BACK LIGHT — Light from behind a subject creating a bright rim to help separation from a background.

BARN DOOR — Two- or four-bladed, hinged shutters fitted to a luminaire to shape the beam.

BLACK LEVEL — The electronic reference level in a video picture signal which represents pure black. Many cameras allow this to be adjusted to suppress shading.

BLACK OUT — To simultaneously turn off all the lights. Most lighting consoles have a DBO (dead black out) switch to make this easy.

BOUNCED LIGHT — Light reflected from a special reflector, a suitable wall or ceiling to produce a soft diffuse effect.

BRIGHTNESS — The perceived amount of light emitted by a source.

C - CLAMP — Standard fixing allowing a luminaire to be mounted on the lighting grid.

CCT — (correlated colour temperature). The closest colour temperature value of a light source derived from a discharge lamp.

CHANNEL — One continuous circuit from the fader on a lighting console through to a particular luminaire.

CHASE MODE — A type of lighting special effect where luminaires are switched on (or off) in a pre-determined sequence.

CHROMINANCE — The part of the electrical video signal carrying colour information.

COLOUR BALANCE — The process of modifying light from different sources so they all equal the same colour temperature.

COLOUR CORRECTING FILTER — (CC filter). A special filter that is used to adjust the colour temperature of a source to the required value.

COLOUR FILTER — (Gel). A coloured piece of material deliberately placed in front of a luminaire to alter the colour of the beam.

COLOUR TEMPERATURE — The relative temperature of a light source expressed as degrees on the Kelvin Scale. Daylight is taken as 5600°K, tungsten as 3200°K. 0°K is -273°C.

CONDENSER LENS — A lens which collects light from a lamp and condenses it to a narrower angle. Used in profile spotlights. The term is sometimes used for fresnel lenses which condense the output from the lamp in the spot position.

CONSOLE — Equipment used to control the brightness level of individual or groups of luminaires through dimmers. Similar to an audio mixing desk.

CONTRAST — The visual range within a scene between the lightest and darkest.

CONTRAST RATIO — The ratio between the brightest and darkest parts of a scene as measured by a light meter. Video cameras can handle ratios of about 1:64.

COOKIE — (Cukaloris). Specially made shapes that are placed in front of a luminaire to cast a shadow onto a background. An example would be shadows of branches made from a piece of 'branch shaped' wood.

CROSS FADE — The lighting equivalent of a mix. One luminaire (or set of luminaires) is faded out whilst another is faded in.

CSI LIGHT — (compact source iodide). A discharge light source with a CCT of approx 4000°K.

CUE — A signal which causes something to happen, as in lighting cue (the point at which the lighting changes).

CUKALORIS — See Cookie.

CYC LIGHT — Special type of luminaire that is designed to illuminate the background curtain.

DAYLIGHT — Light produced by the sun. Nominal daylight is 5600°K, but a cloudy sky may reach 6500°K, bright blue sky may reach 10,000°K.

DEPTH OF FIELD — The distance between the closest and the furthest objects that are in focus. Note: this can be changed by altering the aperture setting.

DICHROIC FILTER — Special glass filter which will transmit selected colours whilst rejecting others. Used as colour correction filters, beam splitters in cameras or to separate infra red (heat) and light reflected from special mirrors integral with a bulb.

DIFFUSER — A scrim or a gel fitted to the front of a luminaire that has the effect of softening and spreading a light beam.

DIMMER — Electronic unit allowing continuous, smooth variation of the power output of a luminaire.

DOWSER — A small metal blade inside a follow spot that enables the beam to be cut off without switching off the power.

DROP ARM — Lighting suspension used to extend a luminaire downwards from the lighting grid.

EXPOSURE — Literally, allowing light to fall onto a photosensitive surface for a controlled amount of time.

F-NUMBER — A set of numbers that indicate the size of the aperture within a lens. Small numbers represent large apertures and big numbers small.

FADE — A smooth change of brightness from a luminaire or a group of luminaires.

FADER — The device that controls fades. Often a slider but, increasingly these days, it could be a wheel.

FALL OFF — The gradual loss of intensity across the width of a light beam.

FILL LIGHT — A luminaire (usually giving soft light) used to control the contrast of a scene by providing extra illumination in dark shadow areas.

FLAG — A piece of shaped opaque material placed so as to interrupt a light beam and either hide the light from the cameras view or prevent a shadow falling onto a particular area.

FLOOD LIGHT — A luminaire giving a broad wash of even (usually soft) light. Often used as a fill.

FOCUS — To adjust the optics of a luminaire to provide a sharp beam.

FOLLOW SPOT — A luminaire mounted onto a stand and manually controlled so that the beam follows a performer as he or she moves around the set.

FRESNEL LENS — A special lens that is made by taking cross sections of a plano convex lens and welding them together to form a thinner, lighter lens.

GAFFER — The senior lighting engineer.

GEL — *See* Colour filter.

GOBO — Shaped cut out fitted into the gate of a profile spot to project a hard edged shape onto a background.

GRID — *See* Lighting grid.

GROUP — A control on the lighting console that will simultaneously affect several chosen channels.

HEAT FILTER — A filter (often dichroic) which removes the infra red (heat) rays whilst allowing the light to pass through.

HIGH KEY — Description of a scene which has large areas of brightness with very few shadow elements.

HIGHLIGHT — The brightest part of a scene.

HMI LAMP — (hydrargyrum mercury iodide). A discharge light source available with a CCT of 5600°K (daylight).

HOT SPOT — A small area within a light beam that is excessively brighter than the overall light level.

KELVIN — Temperature scale used to express the thermodynamic value of a light source. 0°K = -273°C.

KEY LIGHT — A luminaire providing hard light positioned so that the shadows it casts on the subject give an impression of shape and texture.

LAMP — The glass container within a luminaire or lantern which produces light. Also known as a 'bubble' or bulb. Also refers to a luminaire in some sections of the industry.

LANTERN — Another word for luminaire.

LENS — The optical system in a luminaire that allows the light beam to be focused.

LIGHT — The output of the lamp, which is emitted from the luminaire, and controlled by the lighting team.

LIGHTING GRID — The barrel structure, fitted above the acting area, from which the luminaires are suspended.

LIGHTING PLOT — A plan, drawn to scale, indicating which luminaires are to be placed where on the grid and at what level, for a particular scene.

LIGHTING RIG — A plan showing the normal position of the

available luminaires fitted to the lighting grid.

LOW KEY — Description of a scene which has large areas of mid to dark light.

LUMEN — The unit of luminous flux. Measure of how bright a light is.

LUMINAIRE — A unit designed to give out a controlled beam of light. The basic tool of the lighting team.

LUMINANCE — The part of the electrical video signal carrying brightness information.

LUX — The unit of illumination. 1 lux = 1 lumen per square metre.

METAL HALIDE LIGHT — The group name for discharge sources such as HMI and CSI lights. They take two to three minutes to reach full brightness, and cannot be used with normal dimming circuits. Some provide a small degree of dimming control or venetian blind type shutters can be used.

MIXED LIGHT — Light coming from a number of sources with different colour temperature values, e.g. tungsten light in a room with daylight.

MODELLING LIGHT — Light cast from a particular angle to create shadows to show shape. *See* Key light.

NEUTRAL DENSITY FILTER — A filter that will reduce the light passing through it by a known amount without affecting the colour (often shortened to ND).

OHM — The unit of electrical resistance. The electrical symbol is Ω (omega).

OVERLOAD — A dangerous situation where too many lights are connected to the same circuit, causing, at best, the fuse to blow or, at worst, damage to the lighting console or dimmers.

PANTOGRAPH — A Lighting support consisting of a lattice network that can be extended four or five metres below the lighting grid.

PARABOLIC REFLECTOR — A special shaped mirror that will focus a light beam.

PAR LIGHT — The name given to a sealed-beam unit producing an oval-shaped beam. Because the lens is welded to the front of the bulb, both flood and spot varieties are available.

PATCH PANEL — A system of connectors allowing different luminaires to be supplied by alternative dimmers.

QUARTZ IODINE LAMP — (QI). A tungsten filament light which is enclosed in a quartz envelope. The iodine inside the bulb prevents blackening.

REFLECTOR — Any shape or form of material that is used to bounce light, directed at it, back from it in a predetermined direction.

SCOOP — A large luminaire specially constructed to give soft light.

SCRIM — A metal mesh fitted in front of a luminaire to reduce the light intensity. Also textile panels to diffuse light.

SCR — (silicon controlled rectifier). An electronic device used in dimming circuits.

SHUTTERS — Small metal blades fitted in the gate of profile spotlights luminaires to shape the light beam. Also a venetian blind arrangement for dimming discharge luminaires.

SNOOT — A tube placed in front of a luminaire to modify the shape of the light beam by making it smaller.

SOFT LIGHT — Light that casts diffuse or edgeless shadows. Usually comes from a large source.

SPARKS — The electricians in the lighting team.

SPILL RINGS — Concentric cylinders placed in front of a light source to control the spread of the light beam.

THYRISTOR — Electronic switching device used in SCR dimming circuits.

TUNGSTEN HALOGEN LIGHT — Artificial lights which have a tungsten filament. The filament may be fitted inside a normal envelope or a quartz envelope.

UV LIGHT — Ultraviolet light. Light that is emitted by the sun and some artificial light sources but which cannot be seen. Causes burning to the skin and can damage the eyes.

VOLT (v) — Unit of electrical pressure. Europe uses 220 volt, Parts of the USA use 110 volt. Bulbs run on the wrong voltage will either explode or be excessively dark and red in colour.

WATT (w) — Unit of electrical power. The more watts, the more powerful a luminaire's light output.

XENON LAMP — Discharge light which is unusual in that it produces a near continuous light spectrum. Has a colour temperature close to daylight.